D1204288

TALES OF
MANHATTAN
THROUGH TIME

FRANK MUZZY

AMERICA
THROUGH TIME®
ADDING COLOR TO AMERICAN HISTORY

DEDICATION

I dedicate this work to Ameda Lambert Muzzy, an extraordinary woman, actress, writ businesswoman, confidant, and supporter of all things, and mother, Je t'aime.

AMERICA THROUGH TIME is an imprint of Fonthill Media LLC

First published 2016

Copyright © Frank Muzzy

ISBN 978-1-63500-008-5

Typeset in Mrs Eaves XL Serif Narrow
Printed and bound by CPI Group (UK) Ltd, Croydon, CR0 4YY

Published by Arcadia Publishing by arrangement with Fonthill Media LLC
For all general information, please contact Arcadia Publishing:
Telephone: 843-853-2070
Fax: 843-853-0044
E-mail: sales@arcadiapublishing.com
For customer service and orders:
Toll-Free 1-888-313-2665

Visit us on the internet at www.arcadiapublishing.com

INTRODUCTION

A late-night limo ride about Manhattan a dozen years or so ago with Liz Smith, the famed "blonde" syndicated New York columnist, and her party colleague, Elaine Stritch, star of Broadway, film, and this limo ride was the catalyst for *Tales of Manhattan Through Time*. We were on our way from an awards ceremony to the Plaza Hotel for the banquet portion, all very New York; very "Sarah Siddons", when Mz. Smith started up a topic of conversation of the changing architecture of her adoptive domain. The Victoriana of the buildings in Time Square—soon to be replaced with massive glass and steel monolithic twenty-first-century structures—were obscured by massive neon lighted signage much taller than the original bricklayer could ever have imagined. The key phrases in this dialogue punctuating her impromptu night tour of spots of former interest were: "It's a shame what 'we' have lost..." and "what was there, anyway?"

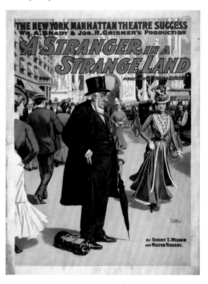

Tales of Manhattan Through Time, in archival and comparative image, tells the tales providing a clearer picture of such transitions in time. It explores the woven journey of strangers in a strange land venturing on a once forested seventeenth century Native American footpath evolving into a twenty-first century of steel and concrete called Broadway and an energy that would just happen to create America's premiere city.

Tales of Manhattan Through Time is the settlement for trade along a canal that would become a trade center for the world called Wall Street, and the site of the first presidential oath of office taken for the new America. It is the growth of the industrial world utilizing a labor force of one group and the riches of another. It is the Vanderbilt's railroading fortunes and their city mansions—seemingly overnight being replaced with the skyscrapers of the twentieth century; and it is the Rockefellers dealing with immovable "hold-outs"—thus the Victorian row houses incorporated into "30 Rock"; and a first known "selfie" and first Christmas tree at Rockefeller Center.

The 1899 Broadway production, note the Dewey Victory Arch, see page 25.

Tales of Manhattan Through Time is the nineteenth century ferry system and the architectural wonders of bridge construction expanding the island and unifying the city of New York and the wonder that they were built at all with the political machine of Tammany Hall. It is the neighborhoods of Circles and Squares, one being the eastern terminus of the Lincoln Highway, the first highway across the United States beginning in San Francisco's Lincoln Park. It is a harbor gift of "Lady Liberty" from one country to another that represents the spirit of America; her torch first mounted in a park as an early fund raiser and the Cleo-needle direct from Egypt showing up about the same time.

Tales of Manhattan Through Time is the museums, the universities and a library that was once a reservoir for city drinking water and now a reservoir for knowledge. It is the sinking of the *Lusitania* pulling us into one world war and the *Manhattan Project* ending another. It is the "victory arches" and parades as well as the romance of ice-skating in Central Park in the winter and a gondola ride in the spring. It is shopping for the world's most famous, albeit cursed, diamond on 5th Avenue and ending up on the "electric stairs" at Macy's and the world's largest most expensive digital billboard bringing the "Grand Canyon" of Colorado to the "Grand Canyon" of "Time Square".

Tales of Manhattan Through Time is a subway transportation system, 100 plus year-old, elevated or not, and a logical grid of Avenues and Streets (once you get out of lower Manhattan). It is taking the A train to Harlem and the birth of the "Blues". It is the center of the American theatre, the Broadway stage—good and bad—successful and not so—and the palaces that housed them. It is earliest television and radio and the movie industry before Hollywood and again today; and, as always, a popular setting and subject, be it stage or cinema, all the way into the future year 802,701 ("The Time Machine").

Tales of Manhattan Through Time is the oldest farmhouse remaining in the city and it is also an 18-story apartment house at the turn of the nineteenth century with a farm with livestock on its roof. It is another apartment house that was possessed by the Devil's "Rosemary's Baby" in a borough that would receive blessings of a Papal Mass with a *rock star* Pope. It is the Ostrich races near Madison Square and the pennant races of early baseball up at the Polo Grounds of Washington Heights, where Babe Ruth hit his first home run. It is the 23rd skidoo in 1906 by police officers to male wolf whistles at the risqué revealed ankle of young ladies and it is the naked singing cowboy in Time Square.

It is the funeral procession of Abraham Lincoln witnessed by a young boy, named Theodore Roosevelt. It is a B25 Bomber plane accidentally hitting the 79th floor of the Empire State building in 1945 and terrorist strike on the World Trade Center 56 years later on 911 and the "Angels over Manhattan".

Tales of Manhattan Through Time is the Dutch land purchase in 1626 from Native American for mere bobbles of shiny jewelry for farmland to the eventual "jewel of the metropolis called Manhattan; a name perhaps derived from the Lenni Lenape language as "Manahactanienk" meaning *place of inebriation*, that would now intoxicate the world (The newly reopened Rainbow Room atop of '30 Rock' does make the best "whiskey sours").

Tales of Manhattan Through Time—with or without gossip in the bars from 207th Street to the Bowery—is an ongoing late-night limo ride heading here to the Plaza Hotel, past and present; and as we arrive to photographers and regrouped with friends—it is—as with any night in Manhattan, the unspoken promise; more tales are about to be created.

Louise and Al Hirschfeld, author Frank Muzzy with Leanora (Mrs. Joseph) Schildkraut, ending an evening at the Plaza, 1996.

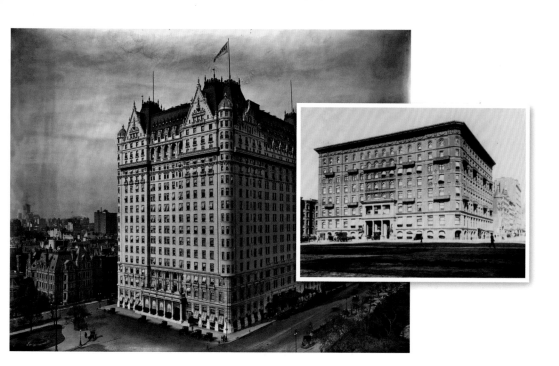

THE PLAZA HOTELS: The first Plaza Hotel, seen here (inset) in 1894, was quite the grand hotel of its day, but paled by "the Plaza" of the turn of the nineteenth century, The 8-story structure although only a dozen or so years "new", was torn down and the Plaza Manhattanites have come to know replaced it as seen above in 1905. Today as folks emerge from the subterranean "Apple" store's glass-cubed lobby— where once stood another grand hotel, the Savoy—they see the locally designed c. 1834 Joseph Hansom carriages parading in front of the Plaza Hotel. A structure seemingly enclosed in glass as a jewel; it is quite a mix of centuries that seem to be the hallmark of Manhattan.

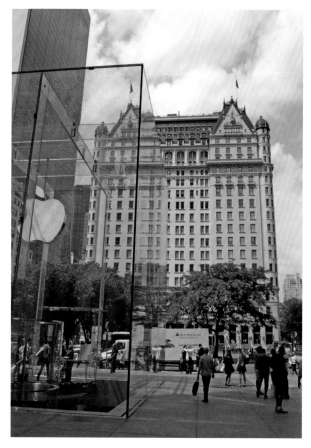

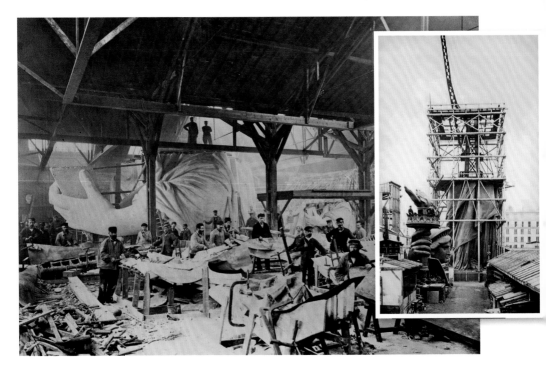

SOME ASSEMBLY REQUIRED: In the Paris warehouse of Frédéric Auguste Bartholdi, his staff stop to pose in this 1882 photo. They are surrounded with the different parts of the statue of "Liberty, Enlightening the World" to be given to the United States on its 100th birthday and becoming a symbol of its immigrant's freedom in New York harbor. Outside was the girder framework that would support the copper figure and loom for a time over the working class Paris neighborhood until its time of shipping. Note the men on the torch (see inset). Below, the finished product in one piece receives daily "Statue Cruises"

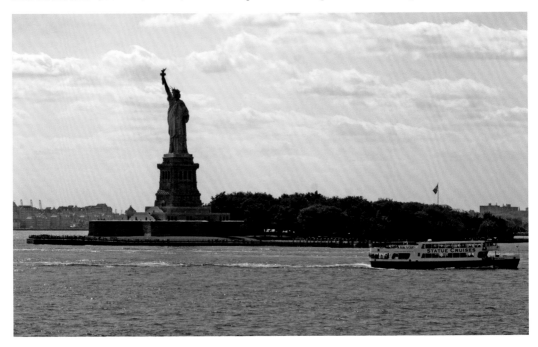

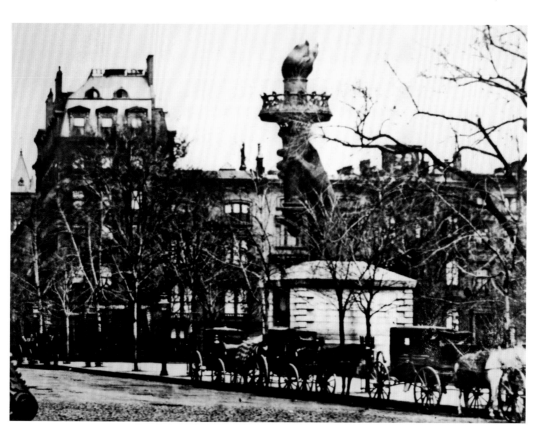

THE STATUE OF LIBERTY OF MADISON SQUARE: Funds were needed for the pedestal on Bedloe Island—that was to become Liberty Island—in New York Harbor. To stir the populace into fund-raising action the arm and its torch resided in Madison Square from 1876 to 1882. Quite the attraction; unlike today, one could go up inside the arm to the catwalk around the flame. Since 1885 the torch has been a symbol of America, and on approach to Manhattan, a most welcoming sight. During the 1985 restoration, brave photographer, Jack E. Boucher was allowed this unique angle. "Next cleaning scheduled, 2085"!

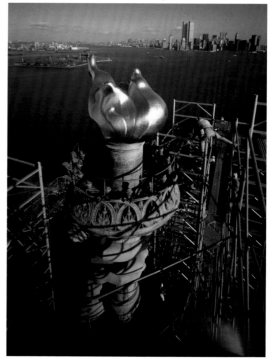

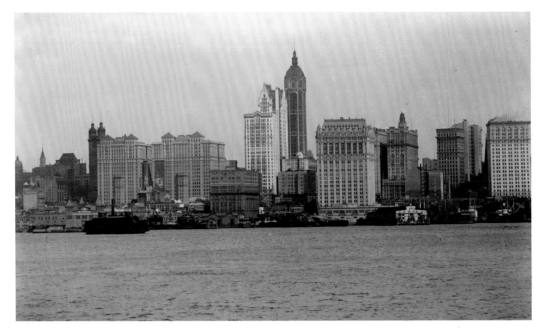

TOURIST TROT: Private firms operated the nineteenth-century ferry service between Staten Island and Manhattan, but since 1905, it has been a municipal service. For most of the twentieth century the ferry was famous as the biggest bargain in New York City. It had charged the same one-nickel fare as did the subway, but as the subway fare increased to 10 cents in 1948; the ferry fare remained 5 cents. On August 4, 1975, the nickel fare ended and the charge became 25 cents for a round trip. This was eliminated all together by 1997. Per Coast Guard regulations, tourists disembark, trot through the Staten Island station to come back around and reenter the same ferry for the return trip to Manhattan. There is a thrill of seeing the skyline on approach, with the Statue of Liberty observing this tourist ritual.

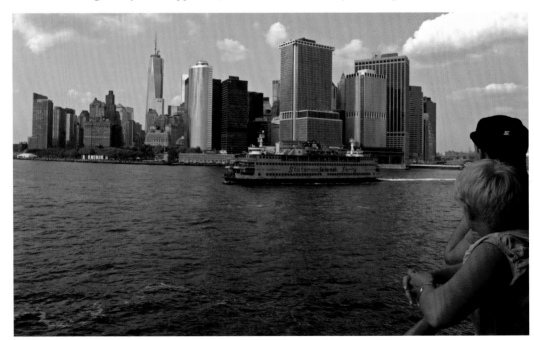

WHITEHALL BUILDING: At the highly visible tip of Manhattan, overlooking Battery Park and welcoming shipping coming into New York Harbor, the 20-story neo-Renaissance-style Whitehall Building was built in 1902–04. Seen here in 1906, within four years it would be joined by the connecting annex; peering over the top referred to as the "Greater Whitehall" and becoming the largest office complex in the city.

The name is derived from Peter Stuyvesant's seventeenth-century house that had been located nearby.

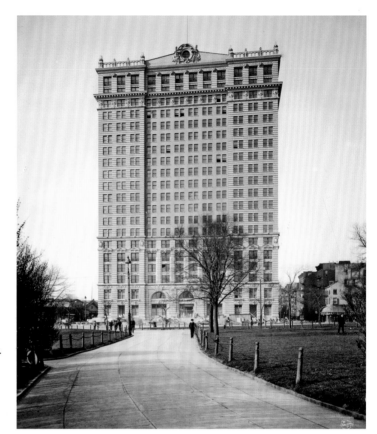

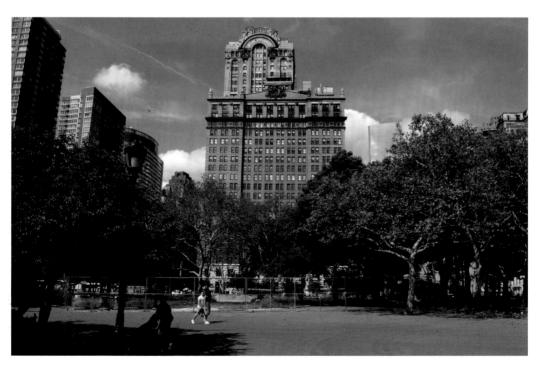

ISLAND FOR SALE: The trees have grown since the 1907 photo was taken from the steps of the then newly-built Customs House. Bowling Green is the city's oldest park and as the Native American tribal council ground, the legendary site of one of the best real estate deals in history—the buying of Manhattan Island by the Dutch in 1626 for a reported $24 in "junk" jewelry. The photo below was captured from the same spot; quite appropriately in timing, with the mayor and city officials paying a visit to the newly-converted Smithsonian's National Museum of American Indians

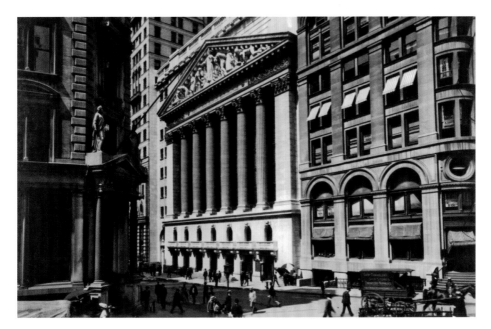

WALL STREET STOCK EXCHANGE: Once an inlet from the East River that Native Americans used for their canoes from Long Island to trade their produce; by 1676 the "broad canal"—really a brook—served the newly-arrived Dutch for their commerce. The entrance later became the original landing for the ferries connecting Manhattan and Brooklyn (later the Fulton Ferry). Trade-generated litter led to the filling-in of the canal to become Broad Street; the new center of Manhattan commerce. Its growth followed with banking institutions and the Stock Exchange (above, center in 1904); and the construction of the Federal Reserve facilities where George Washington took his oath of office as the first President of the new country. The 1835 "Great Fire of New York" burned what was left of the originals Dutch settlement.

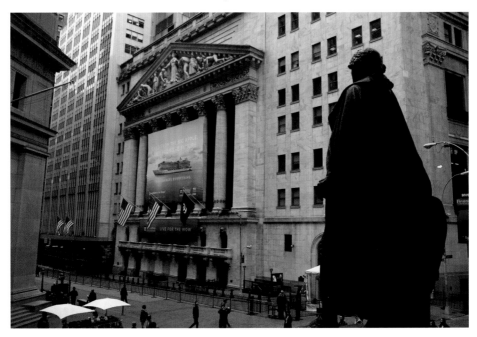

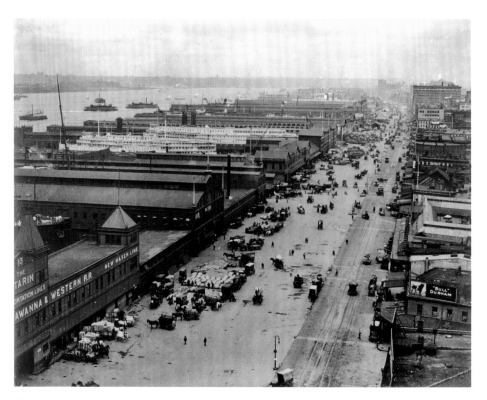

DOCKS AT WEST STREET: The daily life on West Street on November 6th, 1906. Much of the turn-of-the-century commerce for the whole nation came through this port. Today many of the piers are now parks and bike paths while a little more south on West Street commerce rises with the World Trade Center on the right and on the left, on the landfill from the original "Twin Towers" Center construction dig; stands the World Financial Center.

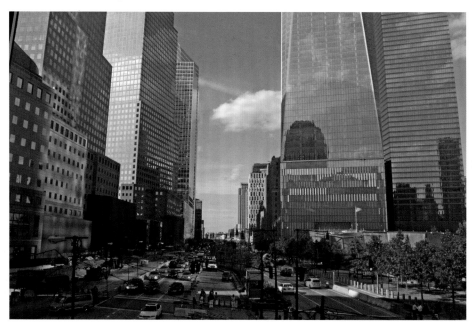

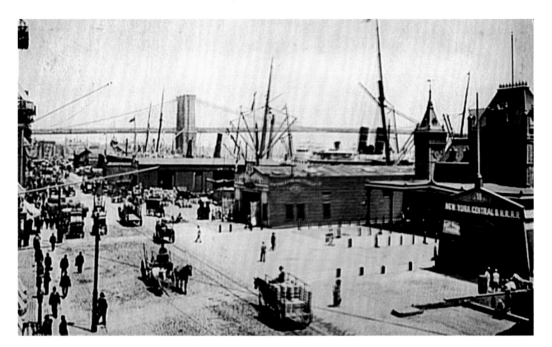

SOUTH STREET SEA PORT: Commercial needs of the city also passed through here—the busiest port in America. Fulton Street (of steamboat fame)—and the always-crowded fish market area—were the commercial canal crossing of lower Manhattan (Broad Street) and the ferry service to Brooklyn from the seventeenth through to the nineteenth century. With the 1883 construction of the Brooklyn Bridge the area was bypassed and by 1900 it became a place most New Yorkers avoided; a symbol of urban decay. Today, following the work of preservationists in the 1980s, the South Street Seaport with its maritime museum and historic vessels (the SS *Peking* seen here); shopping mall and many restaurants, is a New York destination.

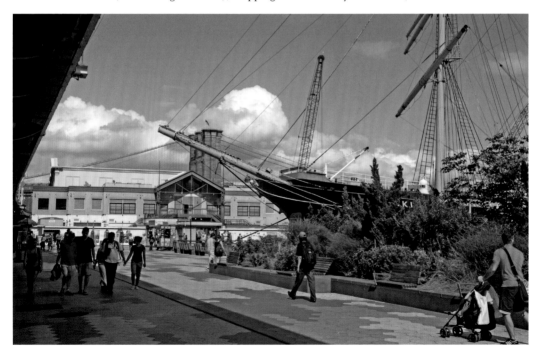

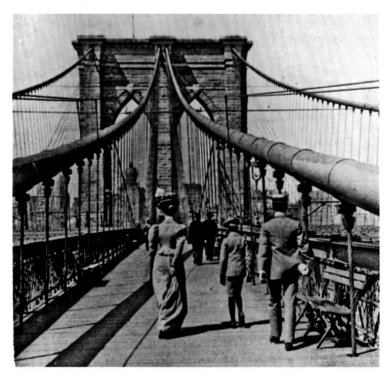

A BROOKLYN BRIDGE BIRTHDAY: A birthday tradition of taking a stroll across the Brooklyn Bridge to Manhattan perhaps started upon the first day of the bridge's completion—May 24th, 1883. Originally referred to as the "East River Bridge", it was designed for the horse and buggy days by John Augusta Roebling. Construction commenced in 1870 and was completed by the designer's son, Washington Roebling. Below, joining the daily 4,000 pedestrians and 3,100 cyclists; author Frank Muzzy celebrates a "major birthday" with his stroll (albeit a bit "King Kong") across the span 125-plus years later.

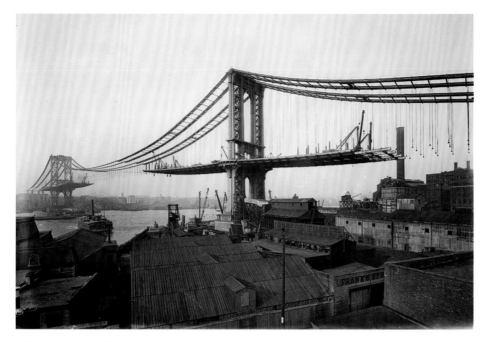

TAMMANY-GATE: The Manhattan Bridge above, photographed on March 27th, 1909 approaching completion, was the last of the three suspension bridges built across the lower East River, following the Brooklyn and the Williamsburg bridges. The design was the first of its kind with cable suspended down to hold up the roadway. It was opened by the end of that year to meet a deadline, and was serviceable but not completed—still missing four trolley tracks, four subway tracks and pedestrian walkway—due to Tammany Hall politics and infighting. By 1912, loose ends were tightened (one would hope) and the bridge was opened, becoming a very popular crossing. Aside from its grand beauty, as it is a toll-free bridge.

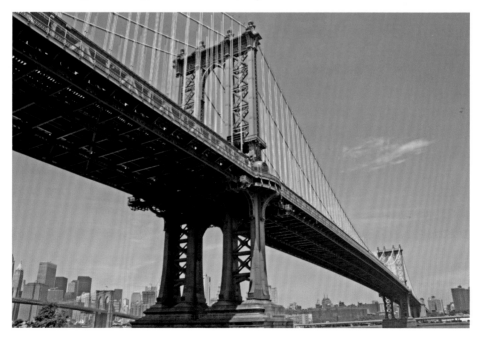

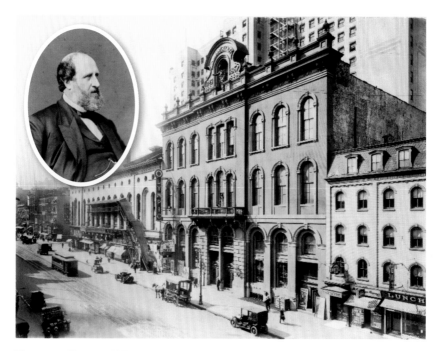

TAMMANY HALL *C.* 1868: The political machine that shaped the city was the "Tammany Hall", seen above in 1910 on 14th street (141 East 14th St.) between Third and Irving Place (4th Avenue). Although the society was around since the eighteenth century—evolving in many pubs and back rooms—it really came to prominence in the early nineteenth by helping immigrant, mainly Irish, make inroads in their new country—albeit a very corrupt and graft-filled system—under the control of "Boss" Tweed (inset) who also lined his own pockets. The hall was demolished in 1927 and the organization continued on 17th street (below) until loosing graft leverage in the 1930s, and it eventually closed in 1943. This last Tammany structure is now dedicated to the theatre arts as the New York Film Academy and the Union Square Theatre, but the chiseled signage remains.

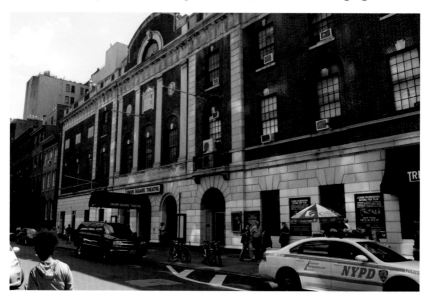

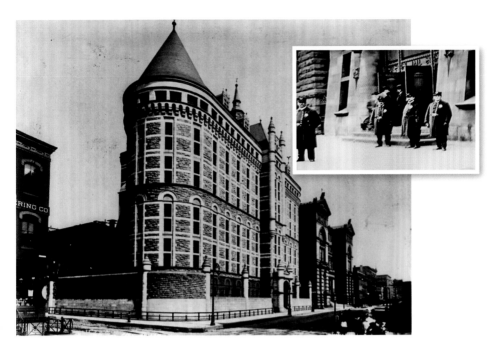

THE TOMBS OF NEW YORK CITY: The prison population of Manhattan was housed here at 125 White Street looking west from Centre Street in 1904. Known as the "Tombs" its reference was to a previous 1838 structure on this same site of an Egyptian motif seemingly resembling an ancient tomb (see inset). At the time Manhattan had a night watchman police force but after 1845 it ended up having two competing forces, ethnically determined. Immigrants largely aligned with the new "Municipal Force", and those of Anglo-Dutch heritage put their safety with the "Metropolitan Force". Eventually, the State militia, in favor of the Metropolitans, settled the riots and the corruption in the Five Points neighborhood between the two rival entities. The Manhattan Detention Complex, the structure currently on this site, is a bit less theatrical and more utilitarian.

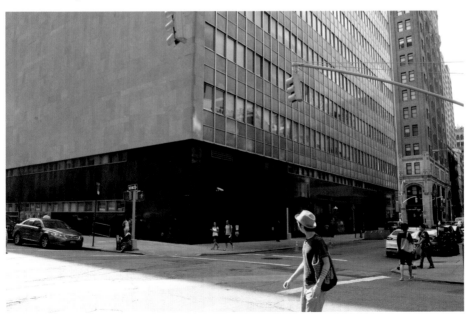

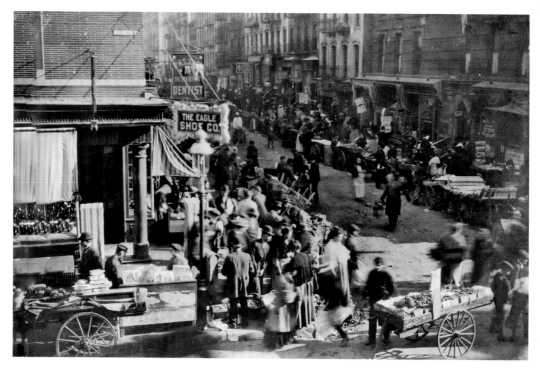

LITTLE JERUSALEM: At the corner of Orchard and Riverton in 1915 the pushcarts of street merchants wheeled through the throngs. There was a vibrant hum of Yiddish from the new immigrants making their way in their new home, but bringing their rich heritage with them. From these streets emanated a culture of theatre and business initiative that have influenced the whole of America.

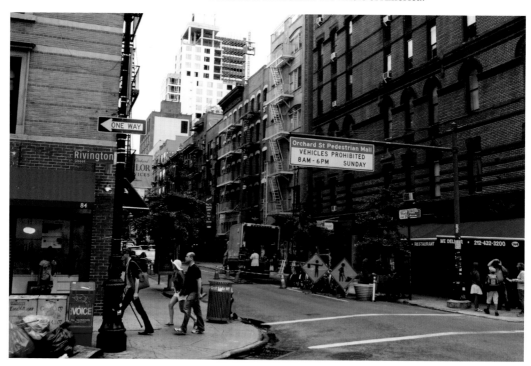

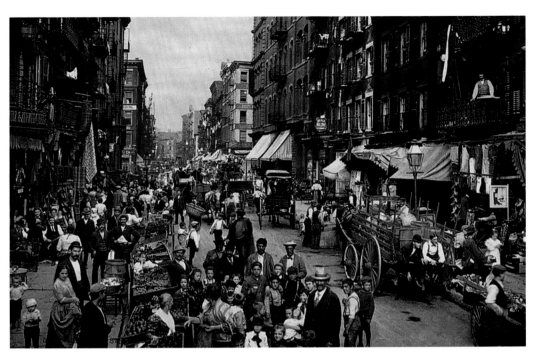

LITTLE ITALY: Neighbors on Mulberry Street *c.* 1900 stop their daily activity to pose for this *Detroit Publishing Company*'s unusual colorized picture. Almost like a movie set, the image is a detail of life in this Italian enclave at turn of the twentieth century. Pushcarts and shops provided everything the Italian immigrants just arriving in America might need, and provide a sense of community in a new world; and even though the edge of the district is now Chinese as the demographics shift, "Little Italy" with a little 'PR' is a destination for the best in Italian cuisine.

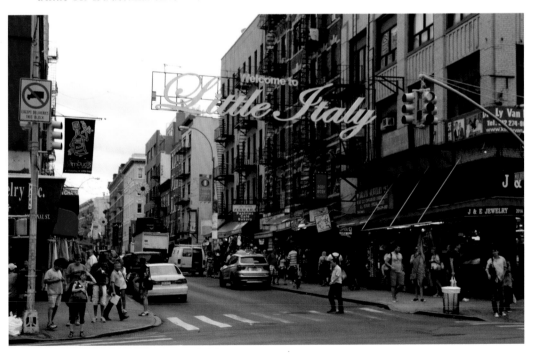

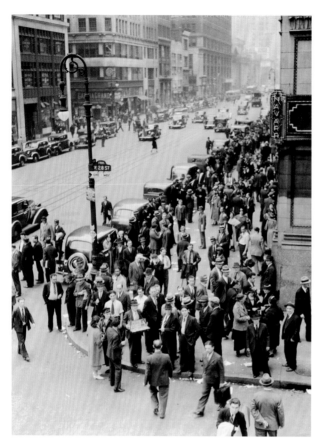

WHO ARE YOU WEARING?
(A nod to the late Joan Rivers).
Clothing the world emanated from
the Garment district seen here in
1936 as "workers" hit the sidewalks
at 7th Ave and 28th. Since the early
nineteenth century this has been the
center for clothing. With machine
innovations, the economically
mass-produced garments could be
delivered by nearby rail or ship. Even
Southern plantation owners would
save labor time and purchase the
inexpensive clothing for their slaves.
By mid-century, ready-made clothes
out-stripped handmade. With East
European labor and the advent of
the sewing machine the wholesale
showrooms and numerous major
fashion labels catered to all aspects
of the fashion process; from design
to production and promotion—an
immigration-driven "American"
industry—and today home to
the "Fashion Institute". (Inset:
Hugh Cosman's 1996 sculpture at
7th Avenue and 39th Street honoring
the fashion district).

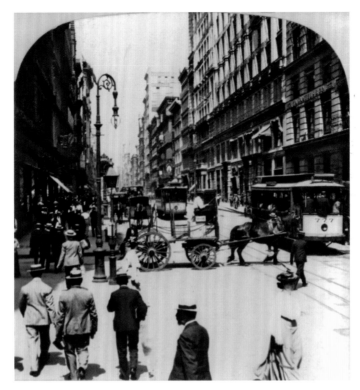

BOATERS ON BROADWAY: Looking north from Prince Street, there is a mix of the "then" modern electric trolley cars and the horse drawn wagons at the corner of Broadway and Prince in 1904. The commercial district is thriving more than a century later; the electric car tracks are gone, replaced in increasing number with hybrid electric cars making their way down Broadway. Dress is more casual with cargo shorts and baseball caps replacing the summer suits and straw "boater hats".

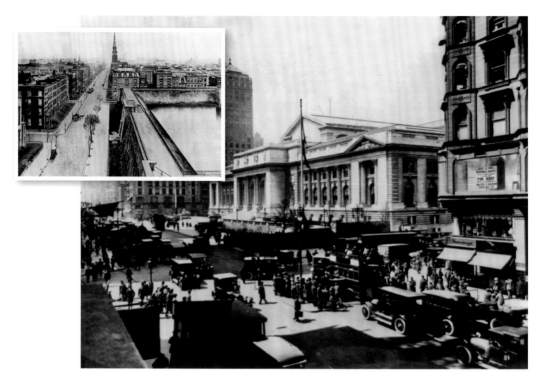

RESERVOIR OF KNOWLEDGE: Croton Reservoir (see inset) Provided water for the growing population of Manhattan as well as a promenade to stroll around the perimeter from 1843 to the 1890s here at 5th avenue and 42nd Street. It was replaced with Bryant Park and the New York Public Library 1895. Seen here in 1917 and again today, one can see some of the original reservoir foundation in the Library stairs on the south side.

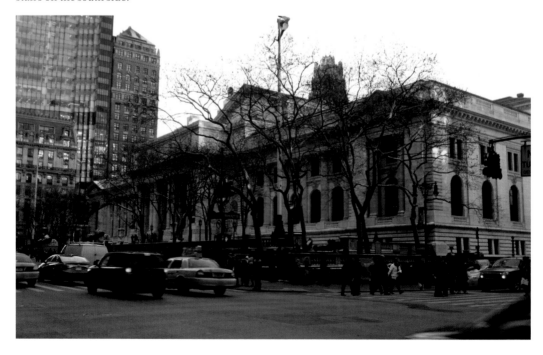

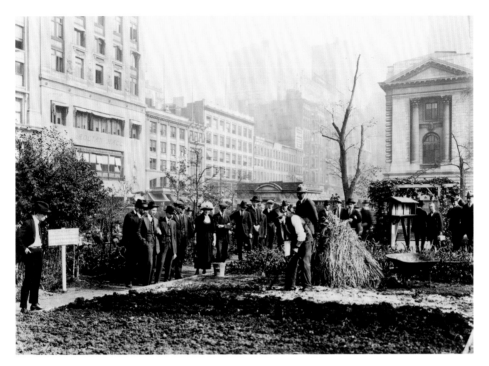

CITY FARMING: Along 42nd Street behind the Library in Bryant Park farming was brought back as a demonstration in a 1922 Manhattan where 50 years before it had been all forest and farmland. Currently there are several urban farms about Manhattan, most notably at the tip of the island at Battery Park. But now on this late fall afternoon, Bryant Park is alive with seasonal porta-shops along same path, and just beyond the ice-skating rink hosts a festive crowd.

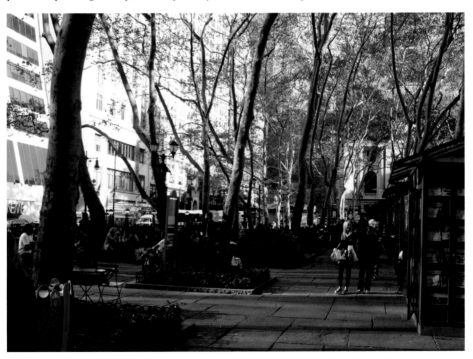

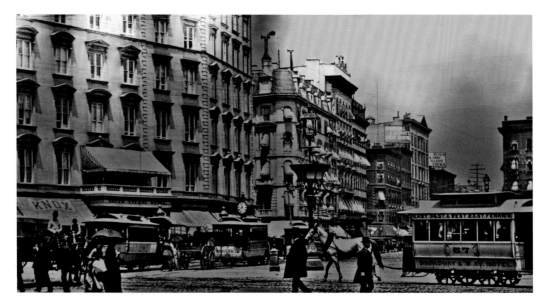

CLOCKING OSTRICH RACES: At Broadway and 23rd, city life in the 1890s and again today. Most structures have evolved with the times as the bustle of the traffic continues. The Fifth Avenue Hotel above, with its landmark clock, (1859 to 1908), had replaced Franconi's Hippodrome; a tent-like structure of canvas and wood accommodating up to 10,000 mid-nineteenth century spectators watching chariot races and other "Amusements of the Ancient Greeks and Romans" as well as the famed ostrich races (perhaps predicating the fashion of plumed ladies hats of the 1880s). Prior to this, the popular corner had served as the eighteenth-century Madison Cottage stagecoach stop. The current structure, the Fifth Avenue Building with its own landmark clock, (now the second clock in this location), was known for most of the twentieth century as the "Toy Center"—and the clock ticks on.

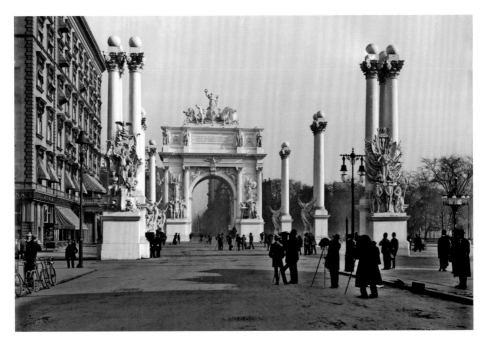

FALLEN ARCHES: A multitude of photographers capture an image in 1901 of one of the elusive "Arches" before it is demolished. Constructed in 1899 at Madison Square, the Dewey "Victory" Arch over Fifth Avenue and 24th Street was for the parade in honor of Admiral George Dewey's victory in the Battle of Manila Bay. Several celebratory arches have been erected at this site. The first in 1889 to celebrate the centennial of George Washington's first inaugural, then two temporary arches were erected over Fifth Ave and 23rd and 26th Streets. The last "Victory Arch" was built at about the same location to honor the city's war dead in the Great War, 1918. As in the other cases, a bid to make the Victory Arch permanent failed.

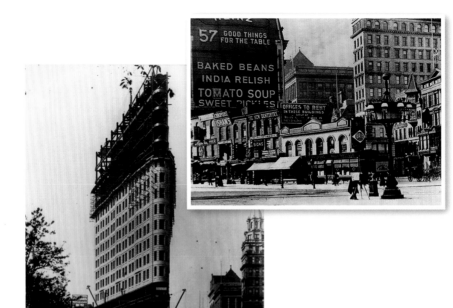

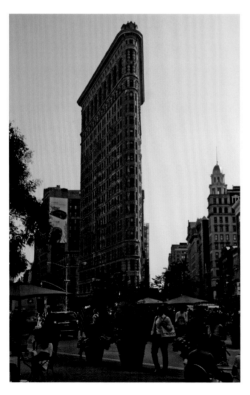

23 SKIDOO: The Flat Iron Building, (Fuller Building) before (inset 1900), and in mid construction in 1902 of the famed architectural skyscraper, one of the first in a trend for the city to expand upwards—the development of the elevator being a contributing factor. Surrounded by Broadway, Fifth Ave, and 23rd Street, its height was a natural for catching the cross-town winds and it was a tradition of the day. Young men would start their evening by watching the women's ankle-covering skirts catch that same wind exposing their modesty. Constables on patrol (cops) would shoo away the "Mashers" and wolf whistles from the corner of 23rd street and hence the origin of the 1906 famous madcap term to start the evening exploits, "23 skidoo".

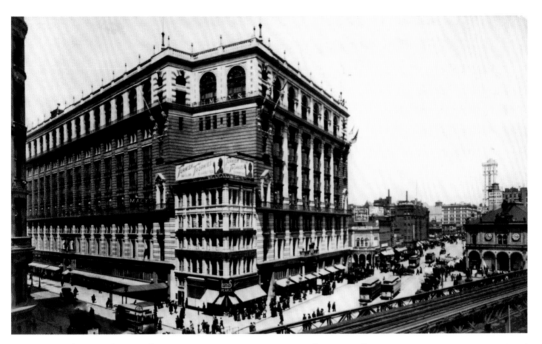

MACY'S AND GIMBEL'S: The 6th Avenue elevated train (1897–1987) —seen above in the lower right of the 1905 image—ran between the two retail giants, Macy's and Gimbel's here at Broadway. Their rivalry was legendary and Macy's seems to be the survivor. Is it a combination of good business, its cinema *real* Santa Claus, or its world-renowned Macy's Thanksgiving Parade that literally has stopped traffic since 1924 (Gimbel's actually originated the parade four years earlier). Aside, Macy's 1902 installation of wooden "electric stairs" (escalator) were the first in the world and still left in operation from Floors 8 to 9, but watch your step, or hands, supposedly someone lost a finger!

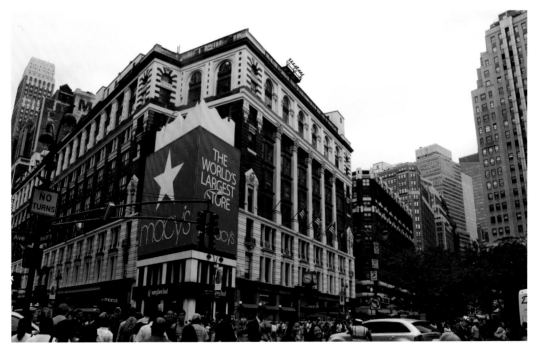

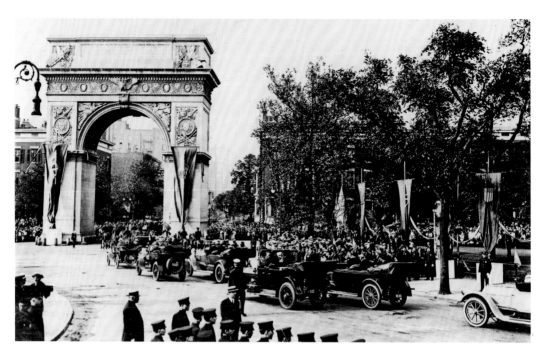

BAREFOOT IN THE PARK: A parade in 1917 passes through the *c.* 1892 Arch in Washington Square on its way up 5th Ave in a time when traffic passed around the fountain. Now free of cars, the Square, much celebrated in literature, theatre, and film over the years, is loveliest filled with people strolling through "Barefoot in the Park" or not. Prior to 1825, the area, then outside the city limits, was a "potter's field" (One oak tree was used for hanging and some say, they see the shadow of nooses); to this day there are some 20,000 indigent, victims of justice as well as yellow fever bodies, buried beneath the park, so treading *barefoot* is quite appropriate.

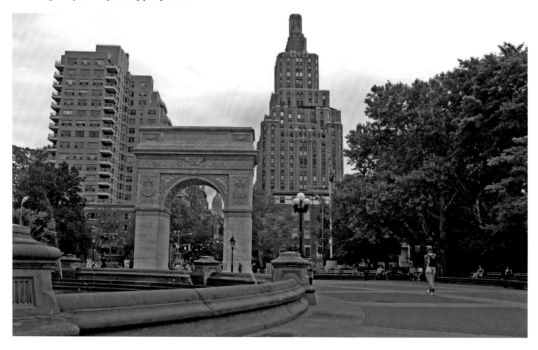

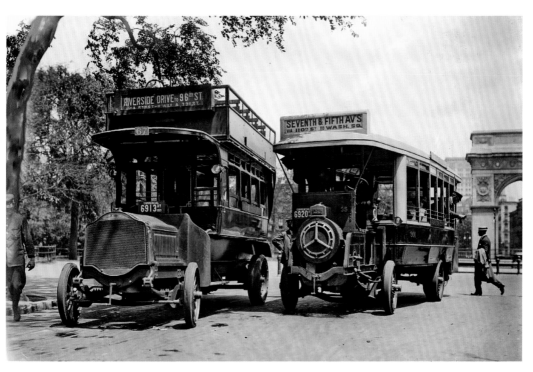

FIFTH AVENUE BUSES: Two buses at the turn around at Washington Square, in 1913. The one on the right is a French De Dion-Bouton model while the double-decker on the left caters to sightseers who wanted a birds-eye view of Manhattan. Below, on a rainy afternoon in the Square, clear plastic ponchos keep the upper deck full of dedicated tourists prepared to dodge the drops and see the sights." Hop on, Hop Off"!

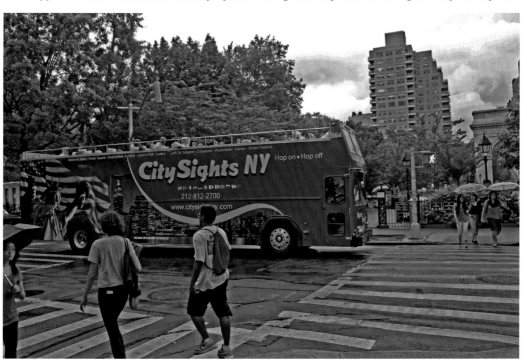

TRIANGLE SHIRTWAIST FIRE: Among the buildings and the comings-and-goings of New York University students and this deliveryman to the left, and just a block from Washington Square, stands a simple 10-story building at 23-29 Washington Place. On March 25th, 1911, at the end of the work-day at the Triangle Shirtwaist Company the hum of the sewing machines was replaced with the screams of 275 young girls between the ages of 14 and 23 trying to escape flames that suddenly erupted in the fabric. Fire trucks, seen in inset below, raced to the scene but there were 44 burnt bodies later found against blocked exits, the remainder of the 146 fatalities—123 women and 23 men—having leapt to the thud on the sidewalk nine floors below. The horror of Triangle fire deaths, the largest industrial accident in New York history, would lead to numerous changes in occupational safety standards that ensure the safety of workers today.

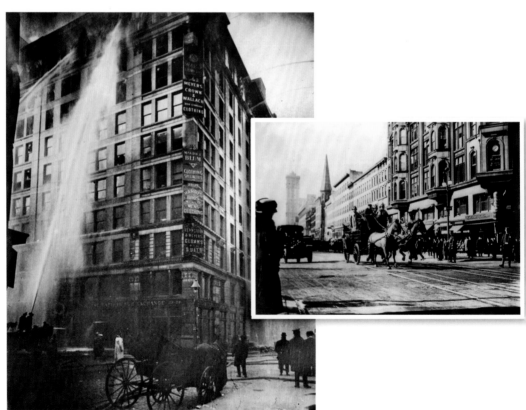

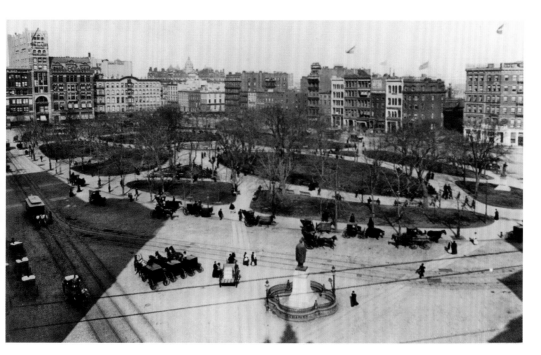

UNION SQUARE 1893: The park was called "Union", as it was the union of several main streets: Broadway, (formerly Wickquasgeck Trail, a Native American foot path), 14th Street, and Bowery Road (4th Ave). Since 1859, a park bronze equestrian statue depicts the historic moment, "Evacuation Day", November 25, 1783, when the British left the city and General Washington triumphantly led his troops back into New York. Union Square is also the original theatre district in the 1800s with the Rialto Theatre and the subsequent supporting restaurants, actor's boarding houses and such in the area. The district slowly migrates north up the street that would become synonymous with theatre, "Broadway"!

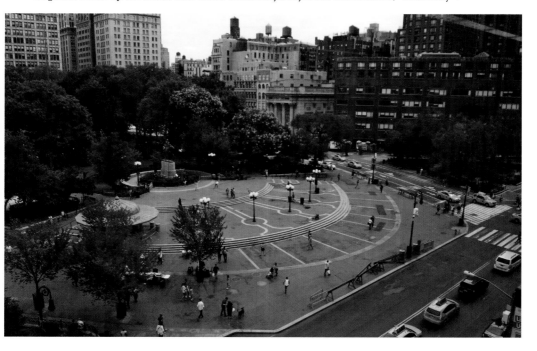

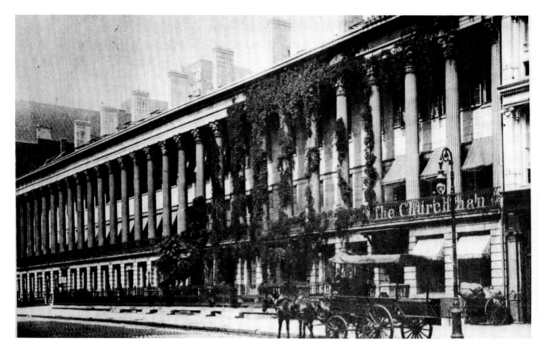

"COLONNADE ROW": Deliveries being made above to the Greek revival row houses, built by developer John Jacob Astor in 1832 as nine upscale townhouses on the former Vauxhall Gardens Amusement Park. The amusement alluded to strolling paths with musical band shell and small theatres. (Amusements remain today across the street at the Public Theatre). Astor named the building for its striking façade of marble Corinthian columns, quarried near Sing Sing prison by inmates. He also named the street Lafayette Place after the Marquis de Lafayette, a hero of the American Revolution. Below, although today only four townhouses remain, deliveries to "Colonnade Row" continue..

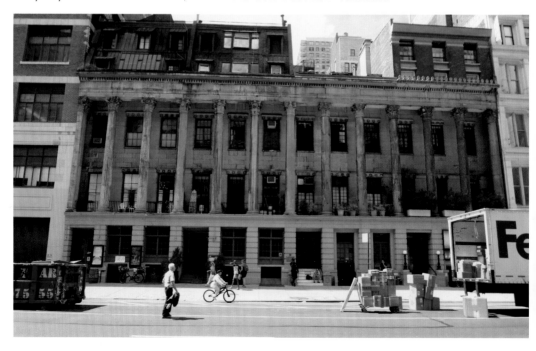

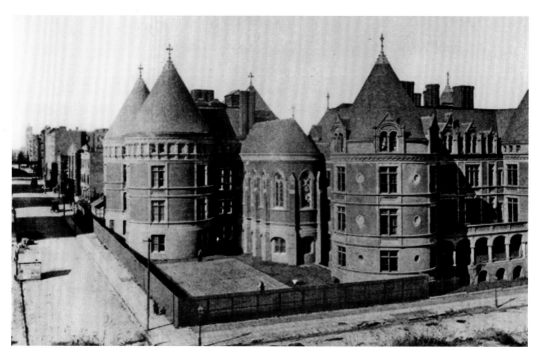

NEW YORK CANCER HOSPITAL: John Jacob Astor III and other philanthropic New Yorkers donated funds and the large home, complete with a tennis court, seen in use, above, at 455 Central Park West in 1884 for the New York Cancer Hospital. This project was spearheaded by the recent diagnosis and deteriorating health of former President Ulysses S Grant (then a resident of Manhattan, and buried in Grant's Tomb). Today it is the romance of its French Chateau design that has made it an important architectural part of Manhattan and part of the condo complex that seem to have grown up behind.

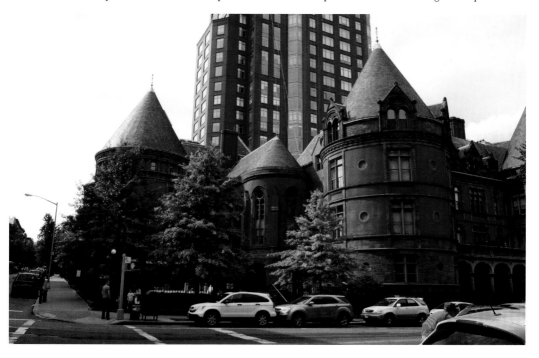

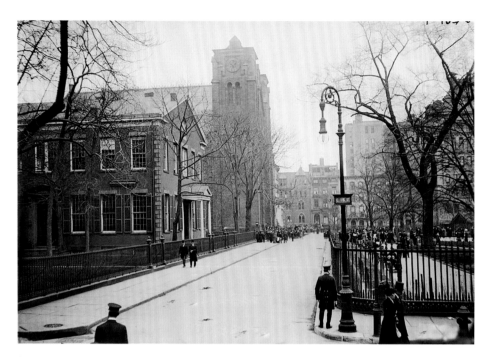

BETTER FENCES MAKE BETTER PARKS: "Stuyvesant Square", the second oldest park in Manhattan, donated in 1836 by the Stuyvesant family (descendants of Peter Stuyvesant, expansionist of the New Amsterdam settlement two centuries before). Of note is the original magnificent cast-iron fence, a response to a family lawsuit against the city because of initial lack of progress required by the bequest of land usage. Remaining quite the fashionable neighborhood, as seen here in 1913 viewed from 15th Street looking down Rutherford Place as the funeral at St. George Episcopal Church of J. P. Morgan, wealthy New York businessman, who in life resided on the square.

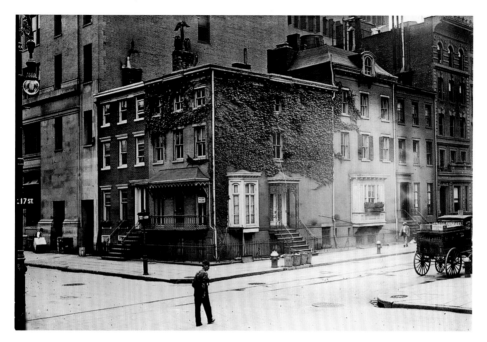

POETIC LICENSE: Despite the street being named Irving Place and the beautiful plaque alluding to such, there is some doubt that Washington Irving, first American author, creator of *Sleepy Hollow*, resided there. But the home (*c.* 1844) above in 1911 occupied by actress and famed party giver, Elsie De Wolfe and her literary agent Elisabeth Marbury, calling themselves "The Bachelors", entertained their social circle, some direct from Dorothy Parker and the Algonquin Round Table (1919–1929). George Bernard Shaw, Sarah Bernhardt, and Oscar Wilde among other luminaries of the day, were often in for tea. It is believed by some that Elsie herself, to keep up with the Round Table's penchant for practical jokes, started the *Washington Irving slept here* ruse.

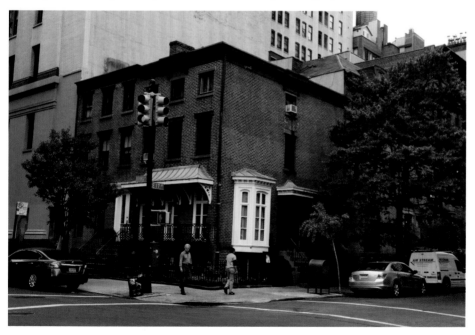

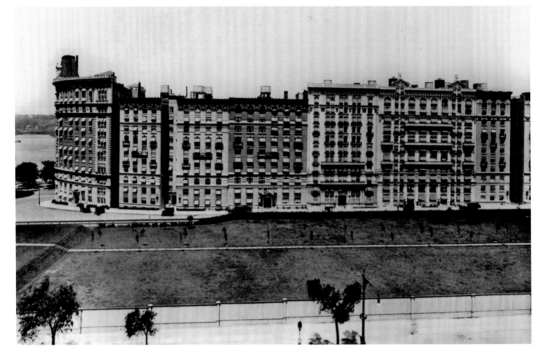

ENCHANTING APARTMENTS ALONG THE HUDSON RIVER: With the development of any vacant lot
on the upper Westside, thanks to the new subway routes in the early 1900s, by 1911 the Claremont
Apartments at 116th Street were welcoming folks uptown. They were a developer's dream with views
along the Hudson River as well as the prestige of the new Columbia University. Note: The end building,
The Paterno, was used for Rob Philip's apartment in the 2007 Disney film, *Enchanted*.

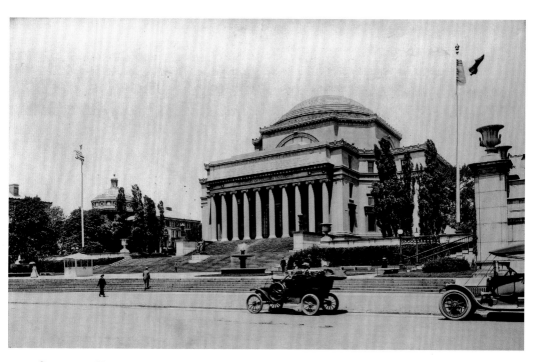

COLUMBIA UNIVERSITY: Upper Westside in 1915 and the campus of Columbia University, the oldest school of higher learning in New York State. Founded in 1754 when originally on Madison Avenue as King's College, it was moved up to its present location in 1896 and renamed Columbia University. Alumni include Founding Fathers, US Supreme Court Justices, Nobel Prize laureates; Academy Award winners, and three United States Presidents. It also administers the annual Pulitzer Prize. Below, the University honors the 150th anniversary of its School of Engineering, just one of some 20 schools.

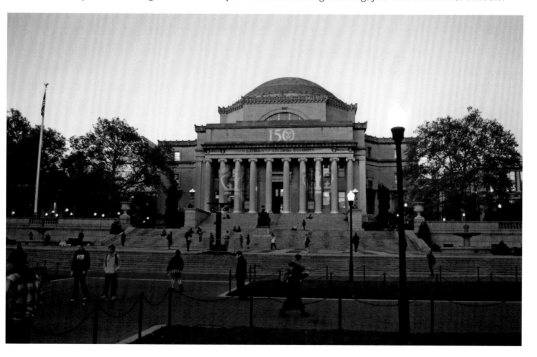

QUICK AS ONE TWO THREE: A gentleman walking south on Amsterdam Avenue from the new 72 Street subway station. AKA "the new 72". Having just opened in 1904, the emblazoned number over the ornate arch of the IRT (Interborough Rapid Transit) line marked the unique above ground station and was part of the original subway line as the first working subway system in New York and has been in continuous operation ever since. Most above ground stations have been replaced by the larger below ground stations such as Time Square. The subway lines were working hand in hand meeting the demands of the new growing upper west side. Grand residential hotels like the Ansonia, seen directly behind the station, had just been built and remain the same today.

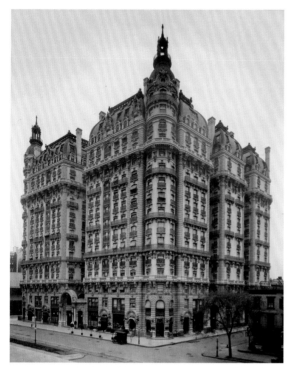

ANSONIA FARMING AND RETREATS:

Getting off the Subway at 72nd Street on the Upper Westside, one cannot help but catch a glimpse of the grand Beaux-Art style edifice of the Ansonia at 73rd and Broadway. To the left is a photo of the structure in 1900. Erected between 1899 and 1904, it was the first air-conditioned hotel in New York and largest residential hotel of its day. For the first few years the rooftop was an urban farm with crops and livestock (including 500 chickens and a couple of milking cows) for fresh eggs and dairy products bellhops delivered to the residence daily. As unusual as that might sound and aside from a small bear kept on the roof, there were live seals in the lobby fountain; the city put a stop to all of this in 1907. By the 1960s and 70s the lower level housed the Continental Baths, a gay bathhouse, where Bette Midler started her singing career with Barry Manilow as her accompanist. In 1977, the club switch-hit and became the famed hetero- swing club, "Plato's Retreat". Today the clubs and the seals have left the building!

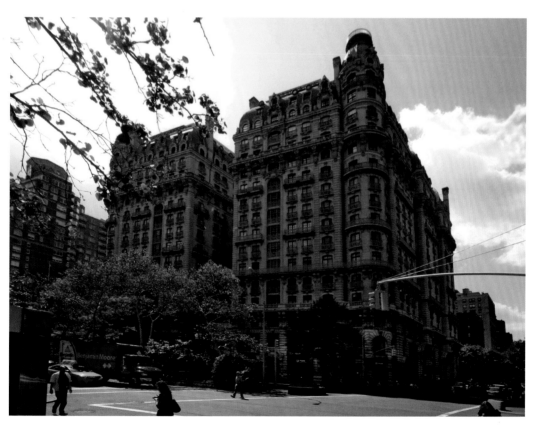

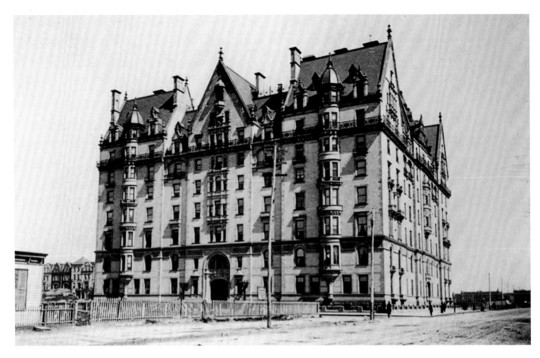

WESTSIDE TERRITORY: The Dakota, built in 1880 so far up on the Westside of the new central park it was named for the Dakota Territory—an equally remote area of the mid-nineteenth century America. Surrounded by "pig" farms back then, today it is rushed hour road hogs. It has dubious fame as the site of Rosemary's Baby and the assassination of John Lennon, (He and Yoko resided on 7th floor and had bought up four other apartments in the building, much to the condo board's dismay). It is also the key subject of Jack Finley's time travel novel *Time and Again*, where the building is a conveyance for time travel back to 1880s Manhattan.

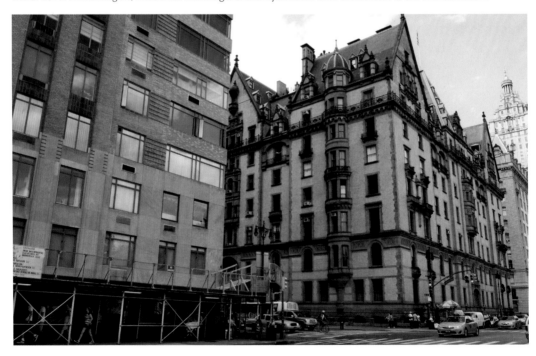

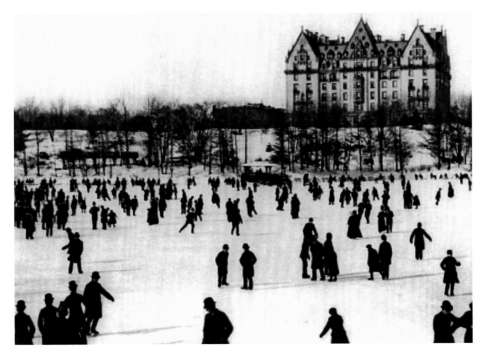

ZAMBONI IN THE PARK: Just across from the "Dakota" in Central Park is the pond where summer rowboats gave way to winter allowing 1890s New Yorkers to enjoy the new fallen snow and afternoon skating. On another snowy afternoon, below, 125 years later just across the park, New Yorkers enjoy the Zamboni prepared Wollman Rink. Opened in 1949 (a donation of Kate Wollman), by 1980 it closed for a two-year renovation. When not completed by 1986, Donald Trump stepped in with City blessing, and completed it in three months; hence requested it is also called the Trump Skating Rink. In the spring thaw it becomes the Victorian Gardens Amusement Park.

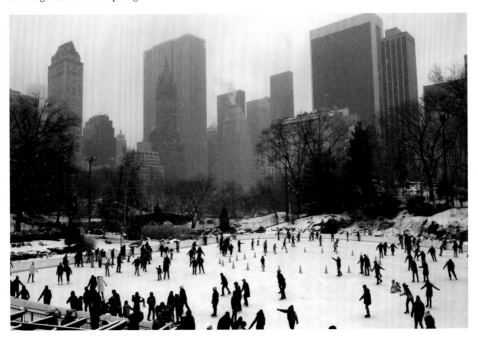

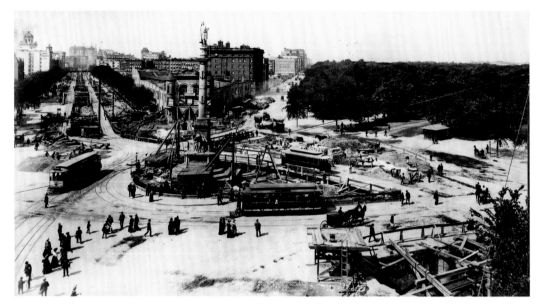

COLUMBUS CIRCLE CONSTRUCTION: As the planner of Central Park, Frederick Law Olmsted's vision included a grand traffic circle at the southwest entrance to the Park as seen here in 1901. Completed in 1905, along with subway construction continuing up Broadway, it became the point from which all official distances from New York City are measured. The Circle's plan also allow, much like Park Avenue, a wider European Boulevard look to Broadway (formerly Bloomingdale Road) expanding the city northward. A century later, the Circle would have an award-winning refurbishing, including a fountain akin to the "Bellagio" in Las Vegas, in time for the completed billion dollar Time Warner Center and upward building surge surrounding the sentinel statue of Christopher Columbus.

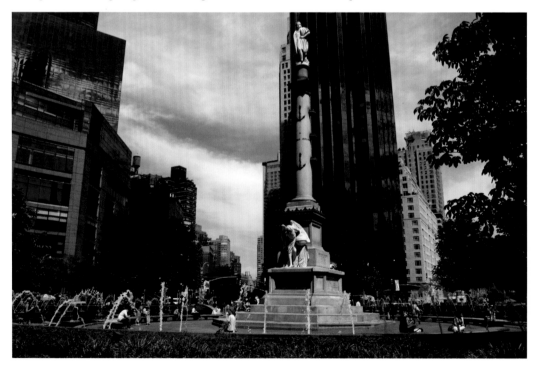

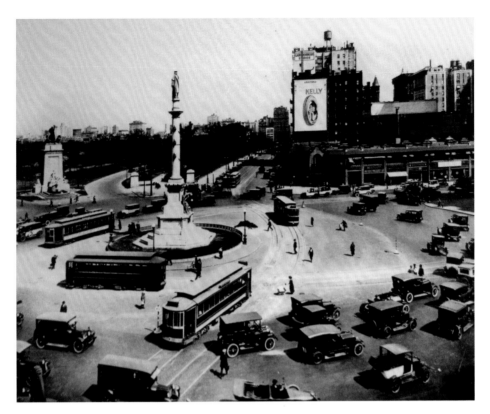

WINDOWS ON COLUMBUS: Columbus Circle looking east in the early 1920s at the crossroads of Eighth Avenue, Broadway, Central Park South (West 59th Street), and Central Park West. Today as viewed from the 150-foot-tall glass curtain wall looking down Central Park South and on the right a balconied late Art Deco moderne apartment building across Broadway, built in 1941. Within the glass curtain are shops, restaurants, residential condominiums and a hotel as well as television studios.

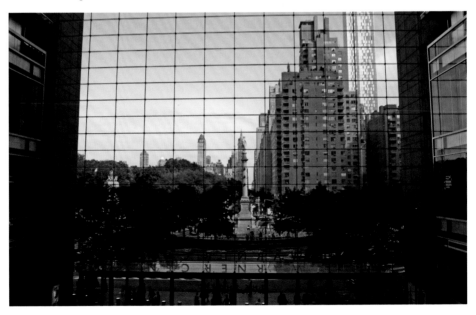

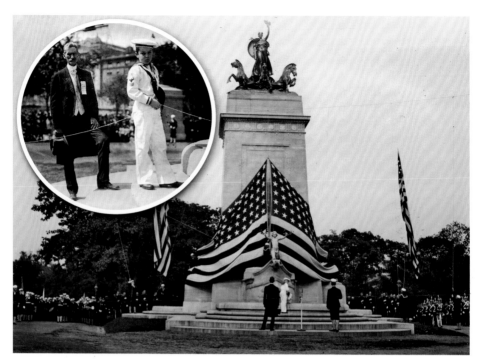

PROPAGANDA IN THE PARK: The unveiling on May 30th, 1913 of the monument at the southwest corner of Central Park facing Columbus Circle, presents a bit of irony as seen in the inset is a photo of George Hearst pulling the cord. For young George was the son of William Randolph Hearst (quoted: "I'll furnish the war!") who along with newspaper rival Joseph Pulitzer, sensationalized, misrepresented or completely fabricated "Yellow Journalism" swaying public opinion and selling newspapers as to why the USS *Maine* mysterious exploded in Havana Harbor in 1898; leading the US into a Spanish-American War in 1899 over Cuba. His headline slogan: "Remember the *Maine*, to Hell with Spain."

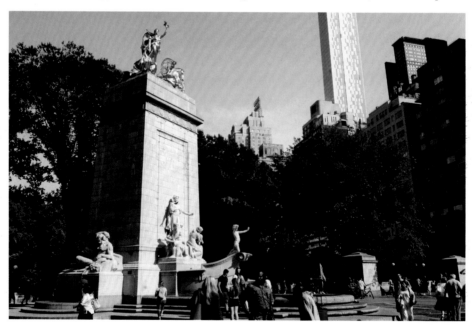

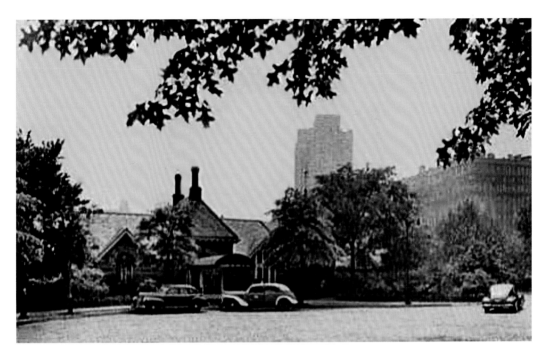

SHEEPFOLD TAVERN ON THE GREEN: Originally the sheepfold that housed a shepherd and his 200 sheep that grazed on nearby Sheep Meadow, the Victorian Gothic structure at Central Park West and 67th Street was built in 1870. Above in 1944, converted and operated as a favored New York dining experience from 1934 to 2009, it actually became the second highest-grossing independent restaurant in the country ($38 million). Even so, due to financial and license intrigue, it closed down and interiors were auctioned off. Below as a young Pedi-cab driver contemplates the view, city strings were pulled and once again Central Park hosts "Tavern on the Green" with new interiors recalling old New York. Try the mutton!

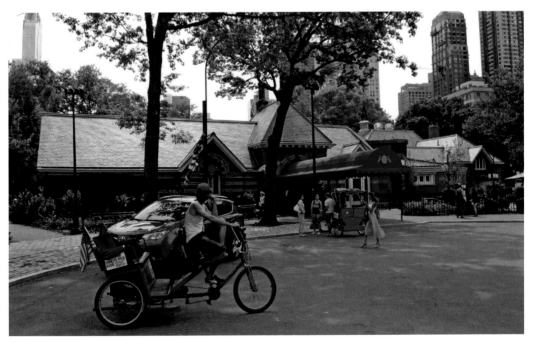

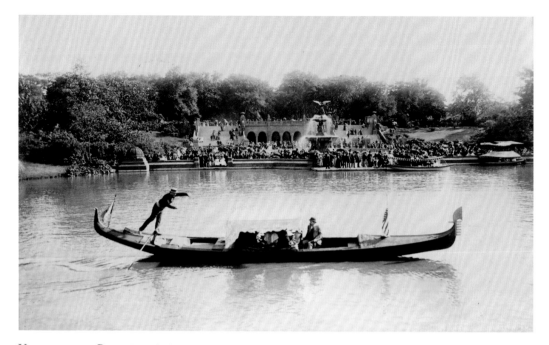

VENICE IN THE PARK: Long before the Venetian hotel in Las Vegas or the canals in Venice California, New Yorkers could glide along in the middle of Manhattan with dreams of Neapolitan romance as here in 1894 with Bethesda Fountain crowds enjoying the theatre of it all, from the original boat rental dock. Gifted in 1862 by John A. C. Gray, a Central Park commissioner, it came unfortunately without a Venetian gondolier to manage it and really just floated unused for years. But by the 1890s, gondola rides were a park attraction, the original 1862 donation continued to be used in the park until the 1980s, when it was finally replaced by another authentically Venetian gondola with gondolier. Today, arranged from the Loeb boathouse, the dreams of romance continue!

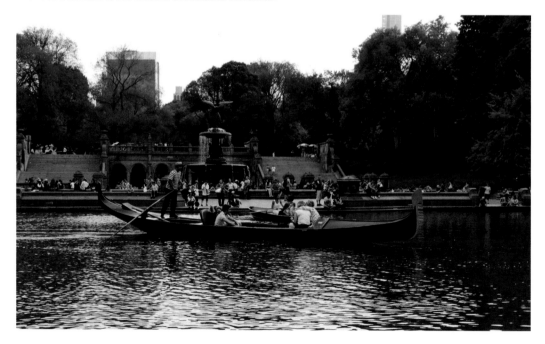

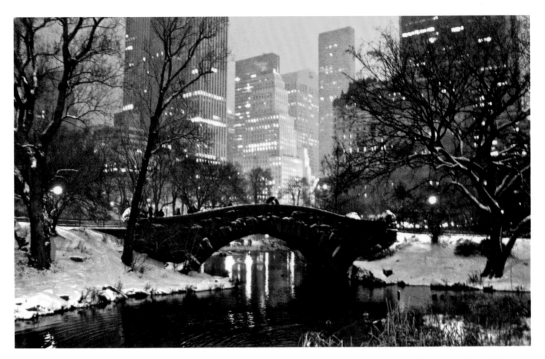

THE GAPSTOW BRIDGE: Curving gracefully over the inlet of the pond at 5th Avenue and 59th Street, on this snowy night in the twenty-first century is one of the iconic bridges, *c.* 1896, of Central Park. It is the second bridge at the site and being a romantic setting, it's one of the 12 most popular wedding picture sites in the park. The original bridge seen below with the swan boats in 1895 was a much more elaborate wood and iron bridge, designed by Jacob Wrey Mould in 1874, but since its building, its constant deterioration from the elements, necessitated a change in stone.

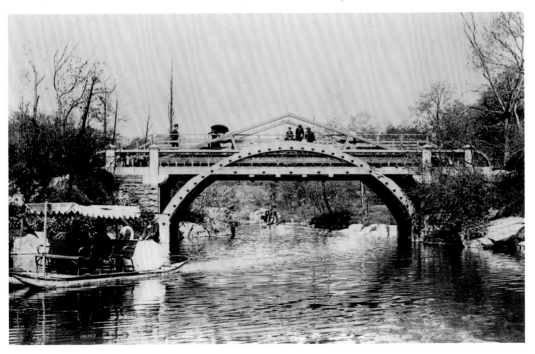

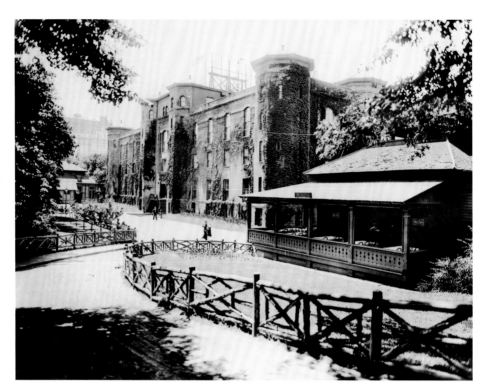

THE "BARK" ARSENAL: On an afternoon in 1914, a photograph of the symmetrical Gothic Revival brick building located in Central Park, at 64th Street off Fifth Avenue. It was originally built between 1847 and 1851 as a storehouse for arms and ammunition for the New York State Militia and predates the design and construction of Central Park. Now on this afternoon it is part of the children's zoo and its nearest neighbors are the barking seals just across the walk housed in the aquatic tank.

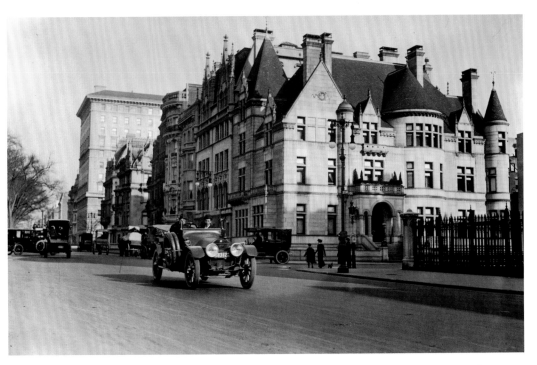

MANOR-MORPHUS: Motoring down from the upper Eastside in 1910 these gentlemen pass the corner of Fifth Avenue and 79th Street just beyond the Metropolitan Museum of Art. The grand Brokaw's single-family home seen here has been replaced like others with multi-resident high-rises; the only clue is the stone and iron fence remaining the same across the street.

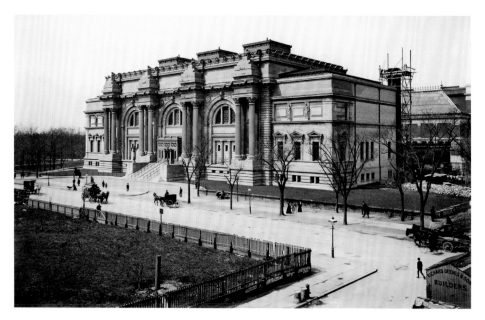

ART FOR THE MASSES: Newly built on 5th Avenue at 81st' Street is the grand salon of art for the city above on a winter's day in 1903. The Metropolitan Art Museum first opened in 1872 (681 5th Avenue), with a mandatory admission charge. Ending that policy in 1940, New York would proudly proclaim their "public museums" were all free. This lasted until 1970 when an honorary trustee, an investment banker, ignoring public opinion, pushed a new city lease of park land to charge a "discretionary" admission. At its present location since 1902 (1000 5th Avenue), the Museum had also gone through several location and architectural design changes. The original constructed start of "High Victorian Gothic" style became outdated before completion and was replaced with a Beaux-art façade. It was expanded in 1910 with the added wings on either side of the original structure as below, thus dominating the city's "Museum Mile", becoming the largest museum in the United States. (And apparently a good place to catch a cab).

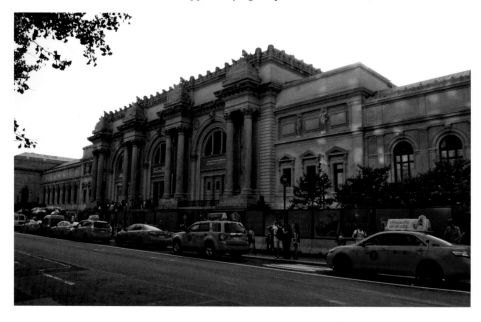

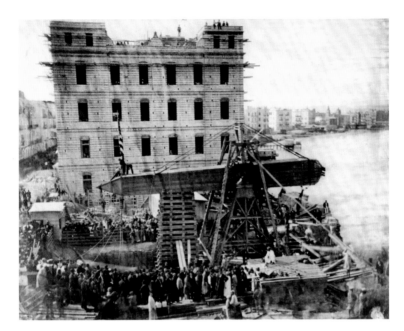

OBELISK IN EGYPT: Here in Alexandria in 1880 and set for travel, Cleopatra's Needle is about to be shipped to New York and find her new home in Central Park. Nothing to do with Mz. Cleo, but 1,000 years older from the reign of the 18th-dynasty Pharaoh Thutmose III making it the oldest outdoor monument in New York. The trip for the 3,500-year-old Egyptian gift first over rough Atlantic seas, then included a four-month undertaking from the Hudson River to its present location; the $100,000 move being financed by W. H. Vanderbilt. At its base (see inset), are four 900 pound, 19-century bronze replicas of crabs which were first placed there by the Romans in 13 BC for stability; theorizing the crab being the symbol of the summer solstice or the sun stabilizing for a few days at its highest point (Tropic of Cancer) and the Roman mythology, associated with Apollo, the god of the sun. The originals are on display at the Metropolitan Museum of Art. *Images below thanks to Centralparkny.com*

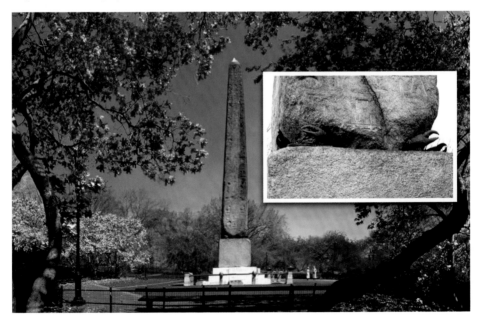

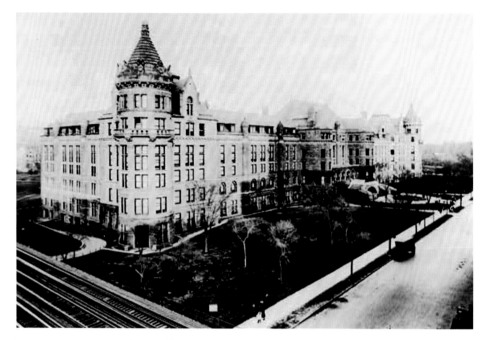

"SPIDERMAN AT THE MUSEUM": The original front entrance of the Museum of Natural History was here on 77th Street but now opens on Central Park West where visitors are greeted with a large equestrian statue of the 26th President Theodore Roosevelt; so honored as one of its major contributors of specimens from his 1909 Smithsonian-Roosevelt African expedition. Note: Teddy's father, Theodore Roosevelt Sr., was one of the founders of the Museum in 1869. This 1913 view of Museum is from the IRT 9th street elevated train platform (it ran along Columbus Ave *c.* 1868–1940). Today, although under the tightest of security, 77th Street is the staging inflation area for the giant Macy's balloons on the evening before their Thanksgiving Day Parade. In preparation, a couple of days before, a city detail arrive and one by one give a quarter turn to the 100 year-old street lights that overhang the street so not to tangle the guide lines allowing the balloons to soar. (Inset: a tethered Spiderman waits hovering over his jeep escort.) Photo of museum below courtesy of Michael Mackenzie Wills, Spiderman inset courtesy of *Spiderman's* blog!

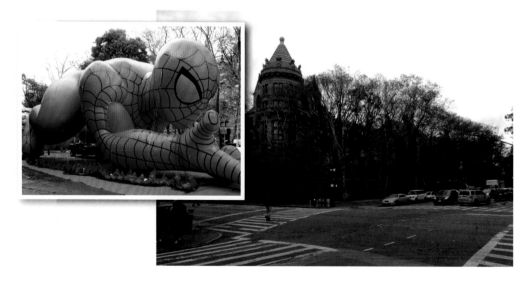

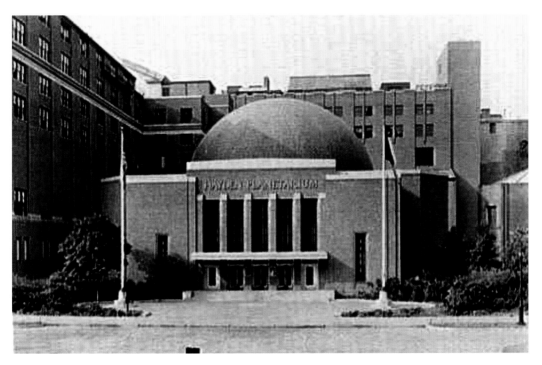

STARS ON THE UPPER WESTSIDE: An addition to the Museum of Natural History on the north side facing 81st Street in 1935 was the Haden Planetarium, with a donation by philanthropist Charles Hayden. Seen above in 1939, it was demolished in 1997 to make way for the new Rose Center for Earth & Space and the new Hayden Planetarium. Reopening in 2000 and billed as a "cosmic cathedral", the Planetarium voiceovers have featured special guest-stars, celebrities such as Tom Hanks, Whoopi Goldberg, and Maya Angelou.

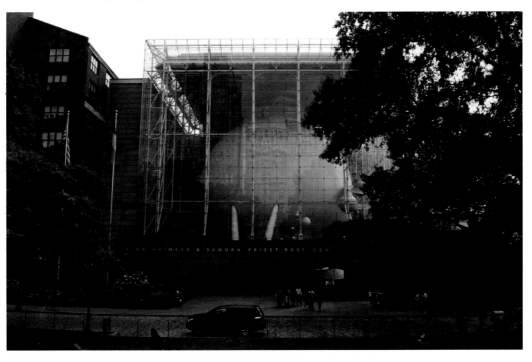

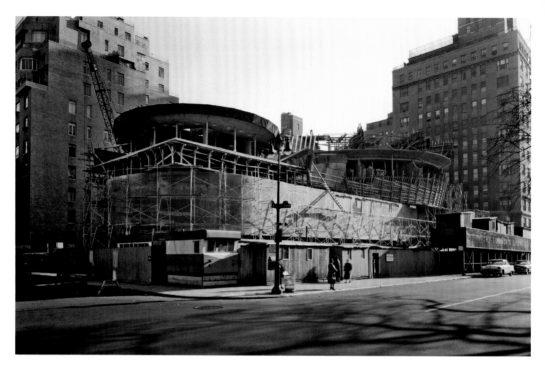

THE GUGGENHEIM: In 1957 the oddest construction project on Fifth Avenue was the new museum at 88th Street. Local "cliff dwellers" took exception as the "stack of dirty dishes" on their Avenue of Beaux-art "Bravado". Regardless, its Frank Lloyd Wright design element (which Wright would not live to see completed) is an exhibit promenade hugging the curved wall while descending floors are best experienced by taking the elevator to the top and strolling down.

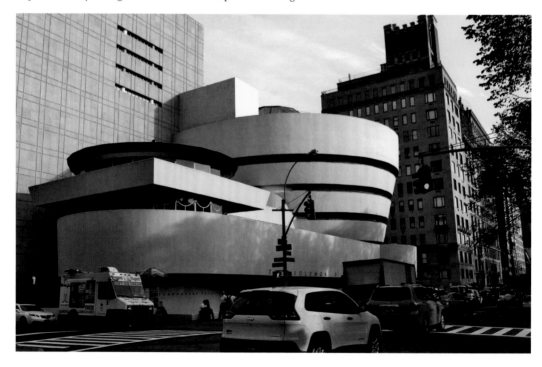

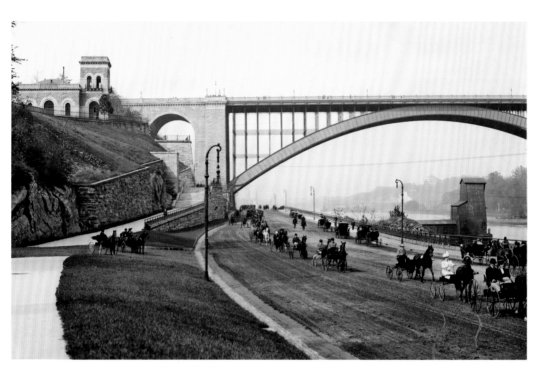

TROTTER TRAFFIC: Today's speeding traffic would leave them in the dust, but it was quite the fashion here in 1901 to "trot" out the Trotters on a Sunday afternoon of "picnics and ponies" along the Harlem River known as the "Speedway". The High Bridge, completed in 1848, remains the oldest surviving bridge in New York City arching over and carrying at one time six lanes of traffic as well as pedestrians connecting the boroughs of Manhattan at 181st Street and Amsterdam Avenue in the Washington Heights to the Bronx.

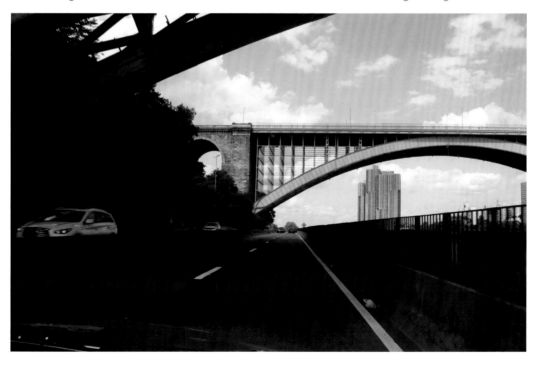

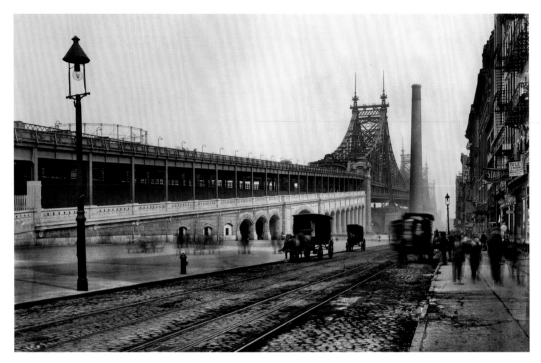

FEELIN GROOVY: Along 59th Street, in 1909 the just completed Queensboro Bridge (known colloquially as the 59th Street Bridge) and the nearby 500 feet tall smokestack of a large steam producing plant of the Consolidated Edison utility company. Perhaps the steam is the source of the urban legend that it was actually smoke from confiscated marijuana that the NYPD would burn and immortalized in the Simon and Garfunkel, song "The 59th Street Song"; *Feelin Groovy*!

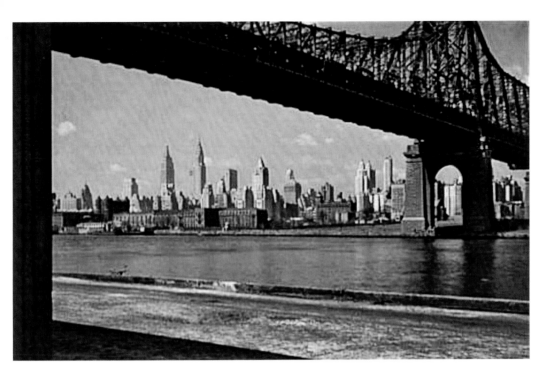

HIDING THE EMPIRE STATE: Beyond the Queensboro Bridge, the new additions to the Manhattan skyline of 1932 with the completion of the Chrysler and the Empire State—the two tallest buildings in the world at the time—and in mid-construction, Rockefeller Center. Below a jogger may not even notice as, along with the UN building, so much concrete and steel have been added surrounding them to somewhat obscure those one-time architectural titleholders.

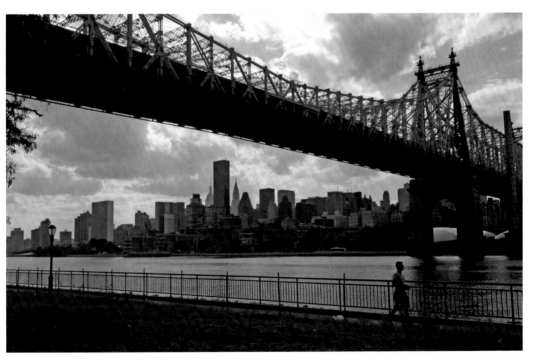

TWO HOLD-OUTS: When buying up the block to build the centerpiece of the Rockefeller center there were two hold-outs as seen from the back in this 1931 photo. No amount of John D. Rockefeller money could circumvent the long-term lease of one 4-story building, a pub, and the apathy of the other so they remain blending in now painted the same color as 30 Rock and few notice and wonder the "tale". The pub location is now serving delicious Magnolia bakery cupcakes. Who knew that cupcakes would become the *cornerstone* of the 2 billion dollar, 8 million square foot center?

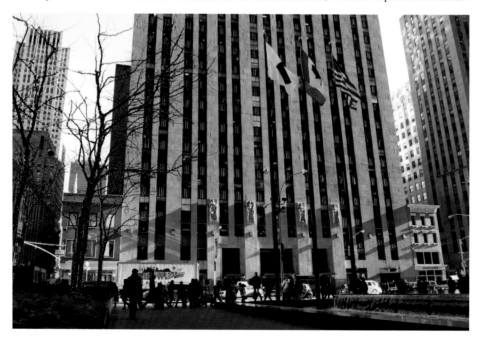

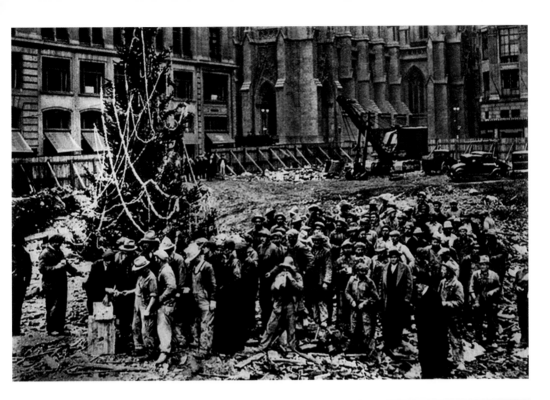

CHRISTMAS TREE AT "30 ROCK":
Construction workers at the new Rockefeller
Center building site (note the view of
St Patrick's across the vacant lot) start a
tradition with the placement of the first
Christmas tree in 1931 and on that same
spot every year a new tree beckons holiday
revelers to 30 "Rock" and the promenade. Ice
skaters get a special thrill looking up as they
glide across the rink below the tree. On this
snowy night crowds saving memories with
their "cell phones" add to the approximately
750,000 holiday visitors drawn to the
donated tree everyday (350,000 normally).
Value of the tree, $25,000; the visiting
experience, "priceless"!

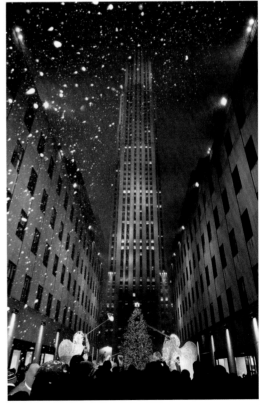

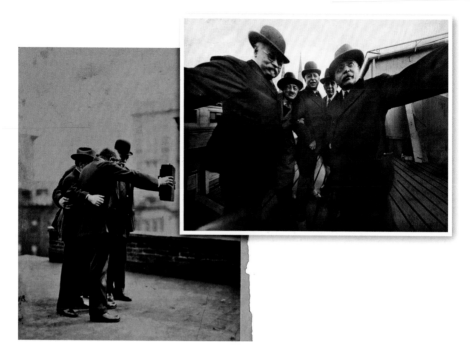

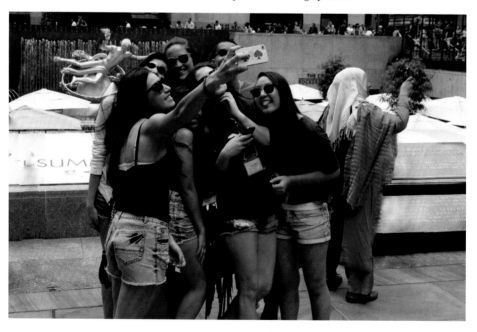

First Selfie in Manhattan: As the "selfie" craze seems to be an offshoot of the digital cell phone phenom, this 1920 selfie of the day, courtesy of The Museum of the City of New York., one of several taken by Joseph Byron of the Byron Photographic studios *c*. 1892 and still in operation, required two people to hold the weighty camera. It is taken from the rooftop of the Marceau Studio, now the promenade of Rockefeller Center, across from St Patrick's Cathedral; the steeples seen in the background. One may assume that there will be in the future a museum exhibit featuring 100 years of selfies. Below at least for now, joyful visitors to the "30 Rock" promenade scrunch into a "selfie" to commemorate their visit. No "photo-bombing" please!

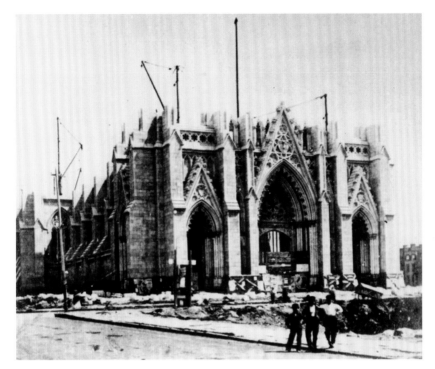

STEEPLES OF FIFTH AVENUE: Construction of St Patrick's Cathedral began in 1858 on land that had once been a Jesuit community college, that of Trappist monks, escaping Napoleonic persecution, and a designated mid-town cemetery. Progress was halted here during the Civil War but resumed to completion by 1878. Today, to accommodate 2,200 of the faithful, quite a few tourists, and a visit by Pope Francis, recent renovations amounted to $177 million. The churches and temples along 5th Avenue bear witness to the growth and changes of Manhattan as they hold their ground. The grand houses of parishioners gone, replaced with towering steeples of commerce.

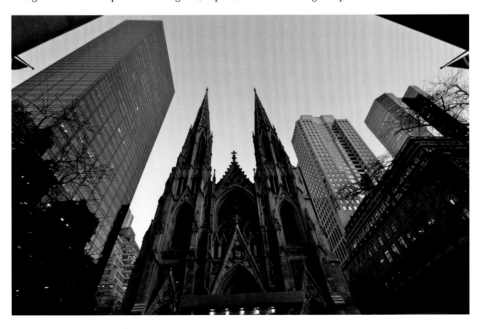

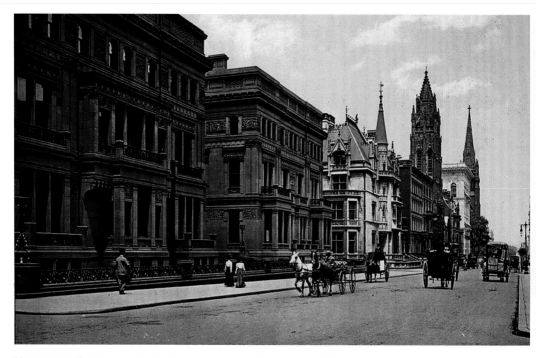

VANDERBILT ROW: A colorized look north from 51st Street along Fifth Avenue in 1900, the street was still unpaved to accommodate the horse and carriage. Perhaps better known by famed journalist Anderson Cooper and his mother, designer Gloria Vanderbilt, as "Gramp's Place", there were 10 of their ancestral Vanderbilt family mansions that would fall to commercial progress within the next 30 years. Another look more than a hundred years later during a break in the Veteran's Day Parade, the remnants of a community of mansions that lined 5th Avenue are their churches amid the high-rises

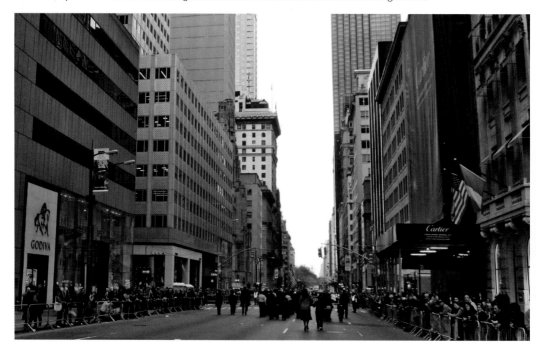

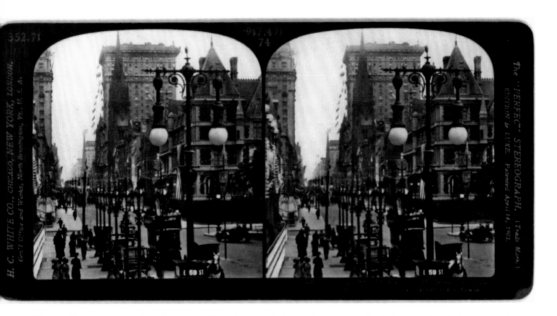

PETIT CHATEAU ON 5TH AVENUE: Looking south from the corner of 5th Ave, and 59th in 1909 using a tourist-collected stereo-optic card to view the comings and goings of the mix of commercial and mansions along the Avenue. The Vanderbilt Mansion, Petit Chateau, on the right built by William K. Vanderbilt, one of the several of the family mansions on 5th Avenue, would be replaced by the Beaux-Arts Bergdorf Goodman department store in 1928.

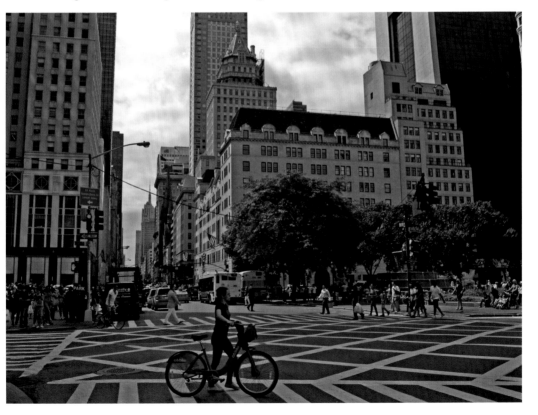

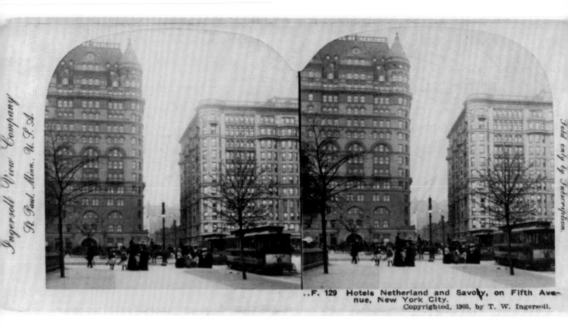

..F. 129 Hotels Netherland and Savoy, on Fifth Avenue, New York City.
Copyrighted, 1903, by T. W. Ingersoll.

VANDERBILT YARD SALE: At Central Park South and 5th Ave. were the stately hotels seen here in a 1903 stereo-optic just across the street from the newly built Plaza Hotel. The Savoy hotel on the right today is now the glass-structured Apple Store and the 33-story, *c.* 1965, GM Building. On the left, occupying the site since the 1890s in two incarnations, is the Hotel Netherland and, since 1927, the Sherry Netherland Hotel. Many of the interior architectural decorative items were acquired for the second hotel from the Vanderbilt mansion, diagonally across Fifth Avenue; being demolished to make way for Bergdorf's.

WINDOW SHOPPING AT BERGDORF'S:
These women passing by Bergdorf Goodman's
on 5th Avenue in 1938 can't believe their eyes
at the totally *avant-garde* window. Utilizing
parts of a piano and enraptured mannequin
the window captures the attention and carries
on the tradition of the Bergdorf's Windows.
Below the "theatre" continues with a holiday
window honoring Al Hirschfeld (1903–2003),
aka "the Line King" who delighted New Yorkers
and the world for more than 75 years with
his own caricaturist take of the celebrities
who "walked" the Broadway stage. A theatre
named for him, Hirschfeld's work was also
known for having his daughter's name, Nina,
hidden a number of times within his lines.
The talent of the window designers have their
take in 3-dimension on both the artist and his
line characters. (Original Hirschfeld works
handled by Margo Feiden Galleries Ltd., NY)
All of which begs the two questions, "How
many 'Ninas' can you find?" and "What will
'Bergdorf's' do next?"

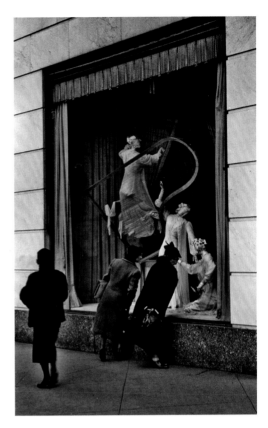

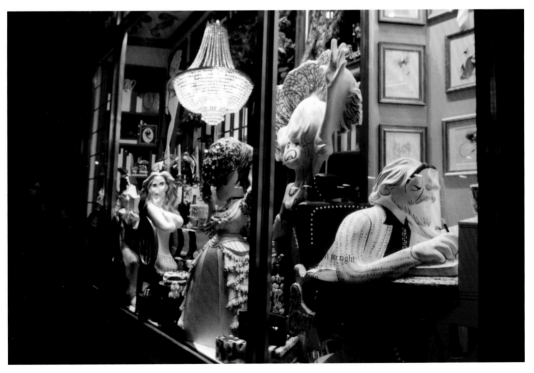

65

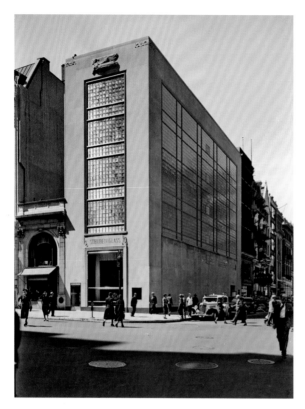

HARRY'S HOPE: Opened in 1934, "Steuben Glass" was the place to buy the American art form of fine glass and many a wedding gift treasure came from the Fifth Avenue store. Now occupied by the famed Harry Winston jewelers, seen below in its holiday diamond décor, it is the place to buy an engagement ring for that wedding or *diamonds by* the *bushel* if you happen to be in that tax bracket. But then there is always window-shopping as you take a 5th Avenue stroll.

Harry Winston was the last owner of the fabled cursed Hope Diamond (see inset). He donated it to the Smithsonian in Washington DC where it is one of their most popular exhibits.

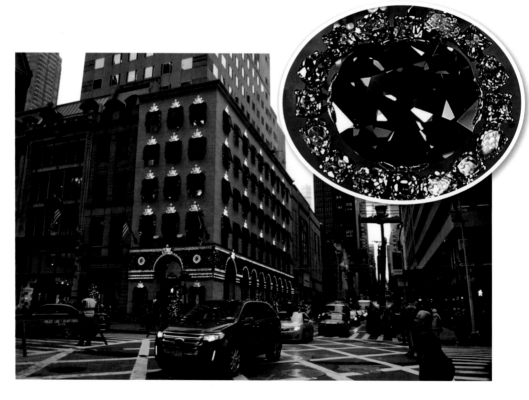

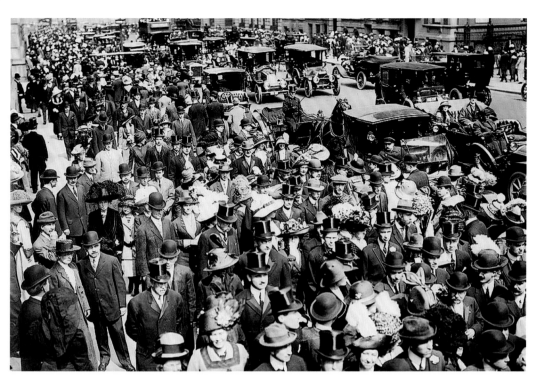

PARADE PROMENADE: No Judy Garland and Fred Astaire, this is the real thing, Easter Parade on Fifth Avenue in 1912; oh the chapeaus! The Avenue hosts most of the NYC parades from St Patrick's Day, Gay Pride, and Columbus to, as below, Veterans Day.

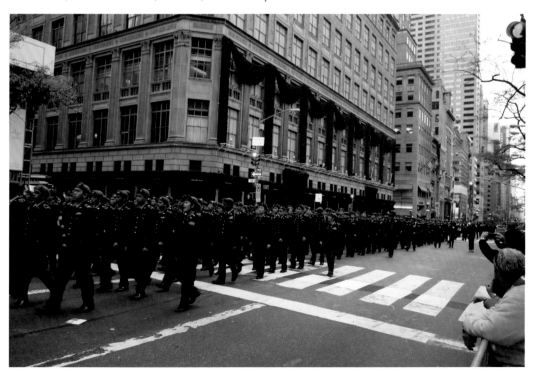

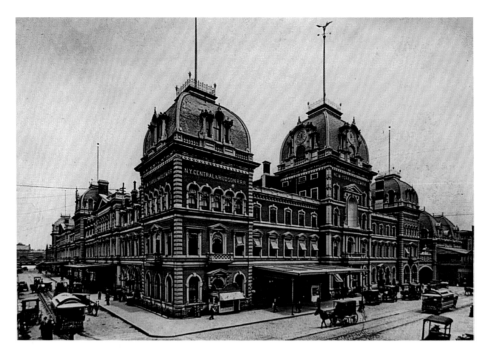

GRAND CENTRAL DEPOT: Shipping magnate "Commodore" Cornelius Vanderbilt acquired the Hudson River Railroad and the New York Central Railroad to his holdings and consolidated his position by creating a rail link to arrive at a common East Side terminal. In 1869, he purchased property between 42nd and 48th Streets, Lexington and Madison Avenue for construction of a new train depot and rail yard. On this site would rise the first Grand Central. Virtually obsolete at the time it opened in 1871, it would be replaced by the second, and eventually the current third by 1913. Note the recent addition of the cast iron eagle over the door at Vanderbilt Ave. one of 16 that adorned the previous Grand Central.

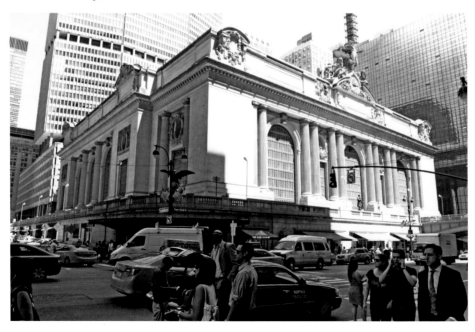

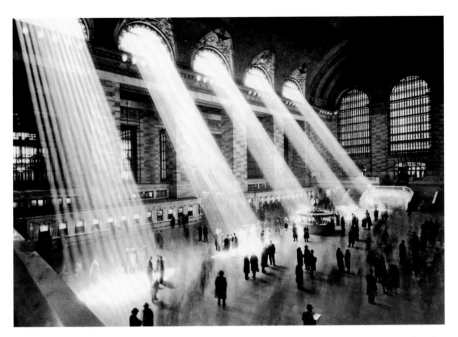

GRAND CENTRAL STATION: Just after the Second World War, 65 million people, the equivalent of 40 percent of the population of the United States, traveled through Grand Central. But unknown was a "secret" platform, no. 61, under the station used by President Franklin D. Roosevelt as designed for Park Ave. access directly into the Waldorf-Astoria Hotel. In the 1950s, before preservationist stepped in, a proposed 80 story I. M. Pei tower, taller than the Empire State Building was planned to top the station. As many of the surrounding skyscrapers may now prevent the sun streaming as shown in the 1935 NYC municipal archives image above. Below, celebrating the station's centennial in 2013, energy from travelers crossing the massive floor has a power of its own.

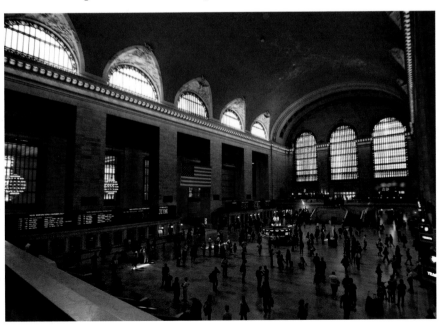

PARK AVENUE AIR RIGHTS: A 1913 postcard look from the Grand Central Terminal's office building at 45th Street, at a more European look for laying out Park Avenue (4th Avenue of the mid-1800s), allowed by a new innovation of electrified trains going in and out of the station. The Vanderbilt-owned New York Central Railroad negotiated air rights (1908–1913) creating empty lots soon to be covered over, as seen below, with planned commercial growth of the city's new age. Note the topped-out building, with a 95 million dollar penthouse, just on the left, a dozen blocks north, the tallest residential tower in the western hemisphere and second tallest structure in New York, dubbing Park Avenue: "Billionaire Row".

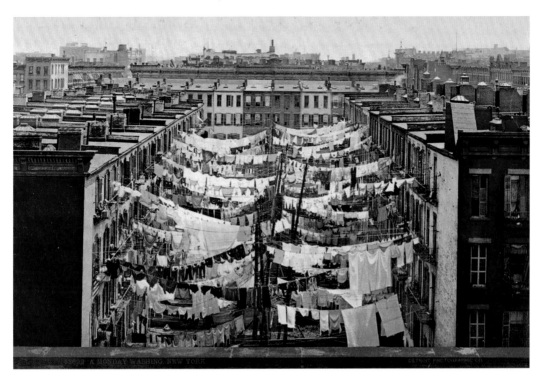

EASTSIDE STORY: In contrast, the sounds of the pulley wheel squeaks on wash day on Park Avenue at 107th Street was common in 1900 as the wash direct from the wringer got the solar treatment. The above colorized-shot was taken from the ledge of the train bridge out of Grand Central station, below from the street level of the same bridge; pulleys have been replaced with the HE, *High Efficiency* machines and matching dryers.

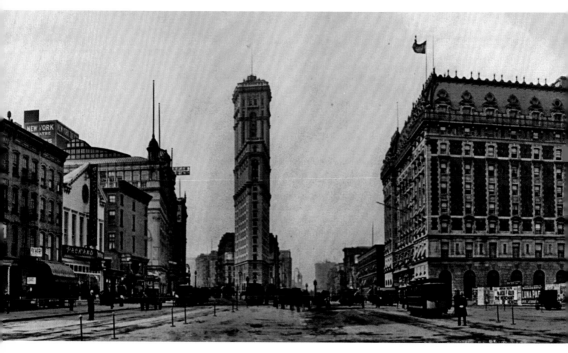

LONGACRES SQUARE REWRITE: About to be renamed here in 1905, Longacres Square would be known as Time Square after the Times newspaper building (center). To the left of the building, the Square's southeast corner, 42nd Street and Broadway would, by 1913, be mapped out as the eastern terminus of the Lincoln Highway, the first road across the United States; today, Time Square is the "crossroads of the world". Below on this evening of November 2014 the premiere of the world's largest and most expensive digital LED sign bringing Colorado's Grand Canyon to New York's Grand Canyon.

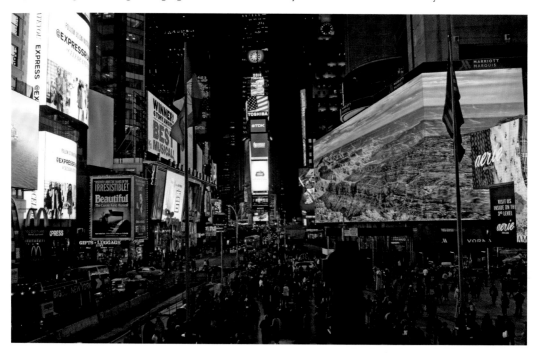

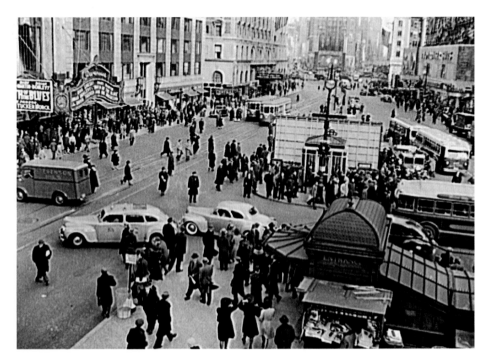

TIME SQUARE TEST: The population of New York in 1941 was 7,597,000, more than twice what it was just 40 years before, but on this Monday, December 15th 1941, the week following Pearl Harbor and America's entry into the Second World War, Manhattan was put to the test to see if folks could get to shelter in 5 minutes, even in Time Square. They rose to the challenge with a successful result if not just eerie as an appearance of a city without its humanity.

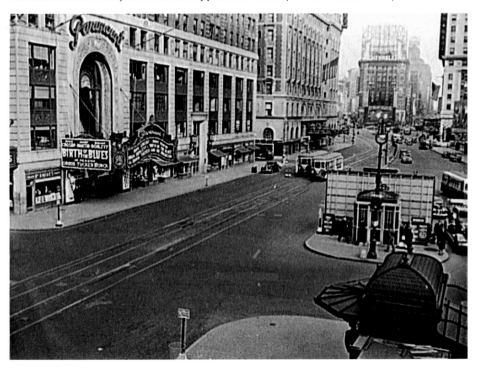

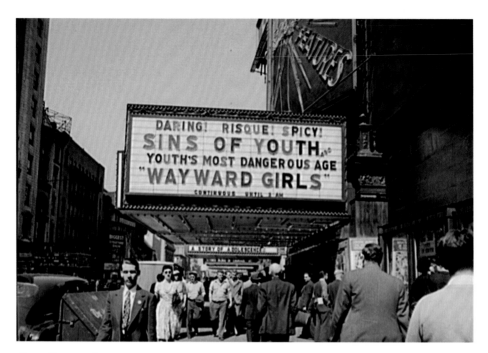

42ND STREET SLEAZE: For years the place to go for the seamy side of Manhattan was 42nd Street, between 7th and 8th Avenue, here in 1942. The downhill sleaze continued into the 60s and 70s until a 1990s revitalization with the city taking over six of these fallen grand theatres. One theatre was actually lifted and moved several lots over. And the Disney Corporation bought the New Amsterdam Theatre to stage the family show *The Lion King*. All scrubbed, perhaps it is the "Disneyana" of Time Square, but again becoming home to legitimate theatre and mainstream cinema, shops, cafés and attractions drawing millions to the city yearly.

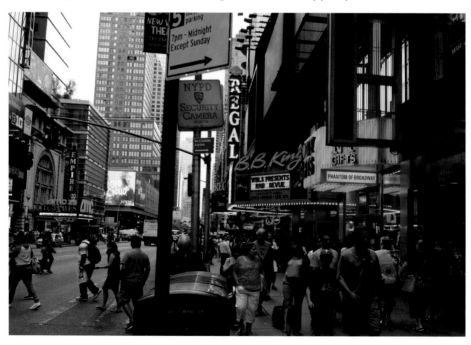

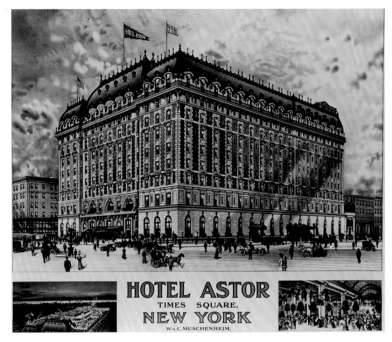

"Pinched in the Astor Bar": The double entendre Cole Porter lyrics refer to the Hotel Astor (1904–1967), located in the Times Square and seen here in poster tribute. Since the 1910s the Astor Bar, aside from its roof top dining and dancing, had acquired reputation as a gay, albeit discreet, meeting place with an entire side of its famed oval bar gaining status in wealthier circles for rendezvous' and pickups assuming legendary proportions. And unlike the lurid late-night pickup scenes at automats, the Astor Bar maintained its respectability. Now a 54-story office building and theatre, One Astor Plaza, at 1515 Broadway is a center for meetings of the business sort. (Not to be missed singing out front, Time Square's own Naked Cowboy).

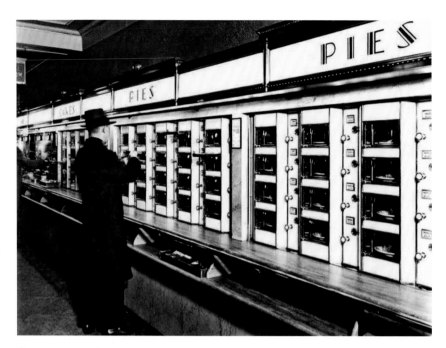

CRUISING THE AUTOMAT: Speaking of which, long before McDonald's or Chipotle the working class of New York would grab a hot meal for 15 or 25 cents or a hot "tomato" at the Automat; a piece of apple pie an extra treat. According to the *New York Times*, "the first automat in the city opened in Times Square on July 2, 1912, a nickel had bought a cup of coffee". Insert the coin and the little glass door would spring open and then shut when you removed the plate. Staff on the other side of the wall then would refill the compartment. As far as picking up a tryst, you were on your own. The Automat scenes from the Doris Day movie, *That Touch of Mink* (1962), show the process. Below, a Wiki-found image records an enterprising retro attempt, short-lived and gone by 2009, called "Bamn" had lunchgoers around St Marks Place taking advantage of the tasty high quality food, with a piece of apple pie an extra treat.

"The Pretzel Lady of Broadway": Today pretzel venders dot the New York landscape, especially around office buildings and tourist attractions. It's hard to resist a mustard treat of a warm pretzel continuing a New York tradition. Here in 1895 there were not many health regulations but lots of folksy conversation. For the corner Pretzel Lady it was a thriving business of pretzels and other baked goods from skills brought over from the old country and for some it was not the treat but perhaps the major meal of the day.

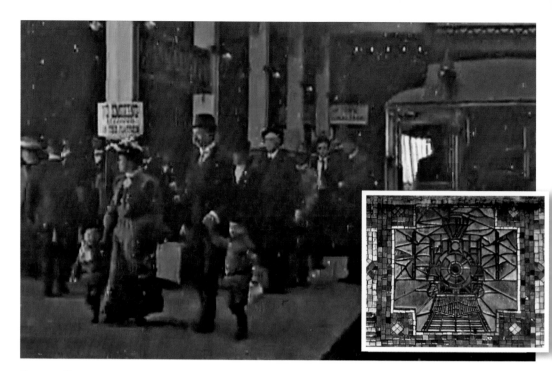

SUBWAY DEBUT: The earliest subway lines ended here at Grand Central Station as seen in this still from *A Subway Ride in New York c.* 1905 and below at the same stop today. When creating the station stops, the walls had mosaic tile signage (inset) indicating what was above at street level, an image for many of the riders who either could not read or as immigrants weren't familiar with English; the tiles remain as the vanguard of Subway art.

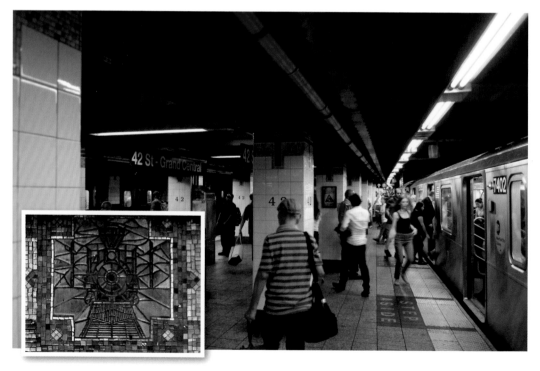

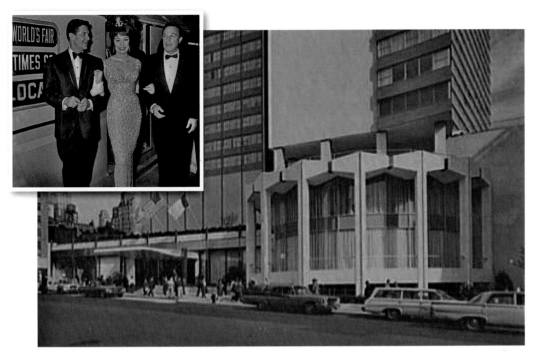

WHAT A WAY TO GO: Built in 1962 for the upcoming New York World's Fair of 1964, the Americana Hotel on 7th Ave. at 52nd, just above Time Square, boasted one of the tallest hotels in New York at 51 stories. There was a special promotional train featuring celebrities from the Shirley MacLaine film, *What a Way to Go* with Bob Cummings and Gene Kelly (see inset) that ran from Time Square out to the "Fair Grounds". The hotel was eventually bought by the Sheraton organization and went through several renovations, most recently 2013. *Inset courtesy of the New York Transit Museum*

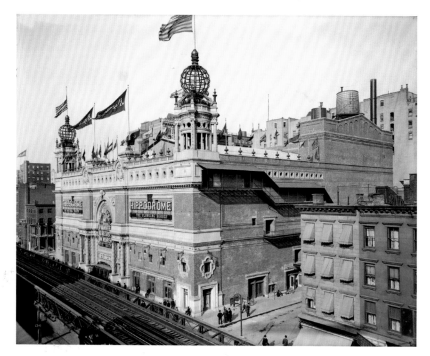

A Disappearing Elephant: Perhaps these passersby (below in inset) have no idea that the Hippodrome whose name is still attached to the office building at 43rd and Avenue of the Americas (6th Avenue) honors its previous incarnation (1905–1939) the world's largest theatre with a seating capacity of 5,300 and the most successful theatre in New York. Its stage, 12 times larger than any other Broadway house, accommodated numerous circuses, Billy Rose's Jumbo in 1935, musical revues of 1,000 performers, an 8,000 gallon glass aquatic tank hydraulically raised and lowered as needed and of course, Houdini's disappearing 10,000 lbs elephant creating a 1918 sensation!

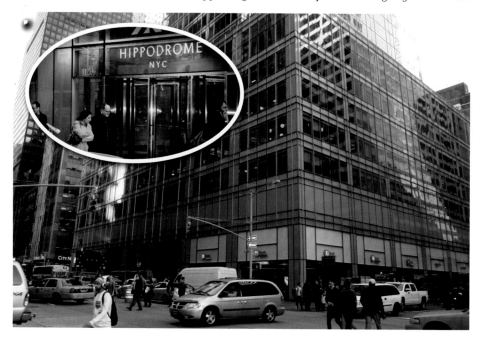

THEATRE PETITE: With less than 600 (original capacity was 300) seats "The Little Theatre" is the smallest theatre on Broadway. Constructed in 1911 (*image on right 1913, Courtesy of the Shubert Archives*), its diminutive size was designed to bring intimate productions to the stage. It was also used over the years for radio and television shows for Johnny Carson, Dick Clark, David Frost, and Merv Griffin among others. By 1983 the theatre was renamed for the actress Helen Hayes when her existing namesake theatre was demolished along with two other theatres, replaced by the New York Marriott Marquis. Tucked between the famed Sardi's eatery and the St James Theatre, "Birdman's roost", it was recently purchased and one might expect another name change for the "Little Theatre" as productions will continue as the Second Stage Theatre.

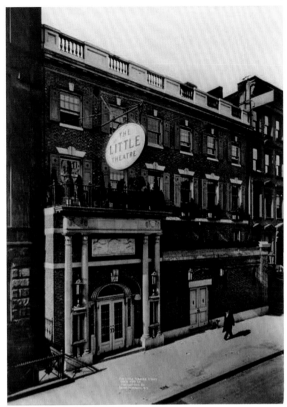

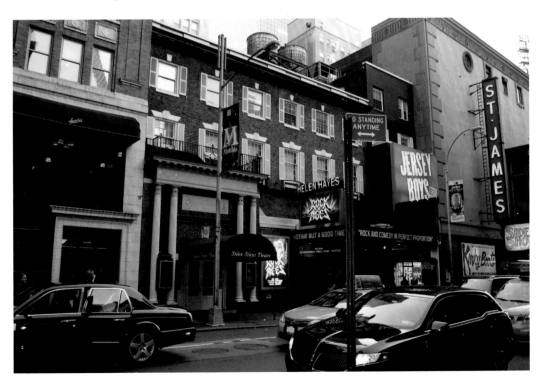

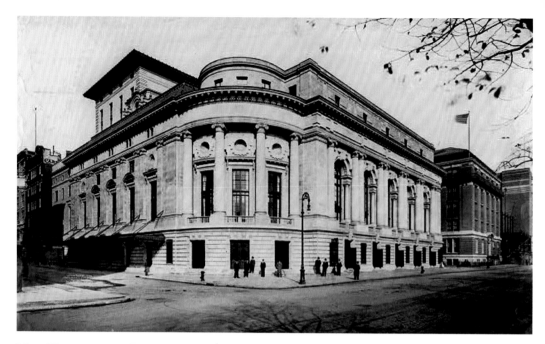

MOST UNSUCCESSFUL THEATRE IN NEW YORK: The New Theatre on Central Park West between 62nd and 63rd as it looked in 1909 when it opened. At a cost of 3 million dollars and seating 2,300 patrons its deficits seemed almost as many. Costly to maintain, bad acoustics and located a mile uptown from the rest of the NYC theatres topped the lists. As well as manager and name changes every other season; The New Theatre, The Century Theatre, The Century Opera House, and once again the Century Theatre, this time managed by Florenz Ziegfeld who in 1917 opened a roof garden calling it the "Coconut Grove". But seeming inevitable, by 1931 it would be demolished and replaced by the "Century Apartments", now ironically just a block from Lincoln Center. Timing... is so important in theatre.

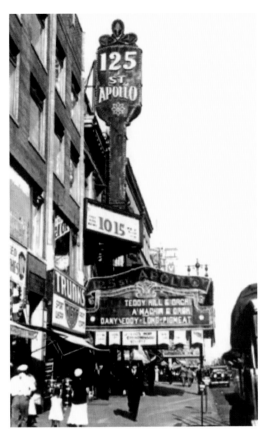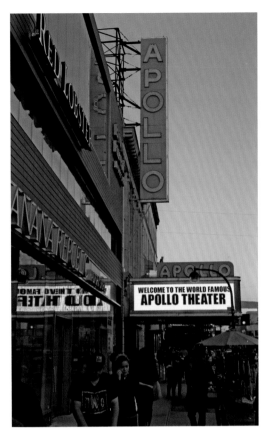

TAKE THE A TRAIN: Once a "Whites-only" Burlesque house *c.* 1914, a city campaign to crackdowns on that *sorta* entertainment, "Burly-Q", resulted in Hurtig and Seamon's New Burlesque Theater to cease and desist in 1933. The following year a new operation gear towards the growing African-American community in Harlem presented full on variety reviews as the "125th Street Apollo Theatre". Immediately, "Audition Night", and later "Amateur Night in Harlem" became a popular nationwide radio broadcast showcasing new black talent not given that chance elsewhere and a 15-year-old Ella Fitzgerald, become one of the first Amateur Night winners.

Established acts, the who's who in black entertainment, as well as some white performers, would be featured the rest of the week and the Apollo became the first racially integrated theater in Manhattan, and one of a few, if not the only theater, to hire blacks in backstage positions.

Much can be said about the importance of this one theatre and the Apollo Theater Foundation (ATF) has archived the history that has reshaped American entertainment, its gift to the world: jazz, swing, bebop, R&B, gospel, blues, and soul.

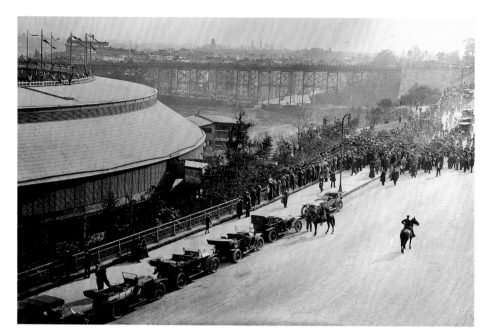

THE POLO GROUNDS: Baseball in Manhattan had several locations with the name, "The Polo Grounds", following each move. The first, just above Central Park between 5th and 6th Avenues, was actual polo grounds for the Fifth Avenue wealthy, but leased in the early 1880s to the Metropolitans and Giants baseball teams. When the city started to lay out the streets uptown in 1889, 111th Street would continue straight through the outfield fence, a bit of game hazard, so the teams moved up to W.155 Street and 8th Ave, seen above as 1920s crowds jostle to enter the stadium. Drawing capacity Yankee crowds as Babe Ruth hit his first home run in 1915 in this stadium, but as a Boston "Red Sox", ouch! Soon he was acquired by the Yankees and by 1922 they moved across the Harlem River to the first Yankee Stadium, "The House That Ruth Built"! But the Polo Grounds remained here and across the street hosting several teams including the Mets until razed in 1964; morphing to the "Polo Grounds Towers" public housing complex (below on far right).

THE CARNEGIE PLAYGROUND: Across 91st Street from the Carnegie Mansion on Fifth Avenue there was a playground for the neighbor athletics in 1911 as kids scramble for the ball. Today there are still a lot of urban playgrounds, maybe not on 5th Avenue but as below on Randall Island, under the Triborough Bridge (now the Robert F. Kennedy Bridge) where older "kids" scramble for the ball as the "Gotham Knights", Manhattans own gay rugby football club play the DC "Scandals" (nee: Renegades); ♫ Gimme scrum! The Manhattan team won ♫!

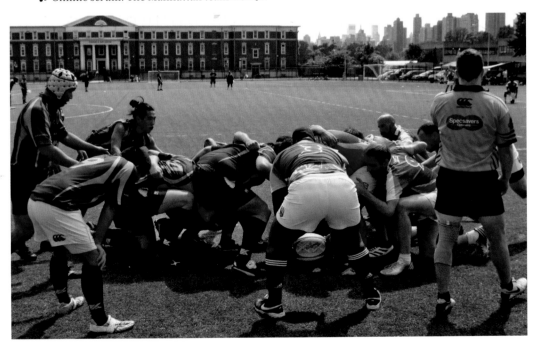

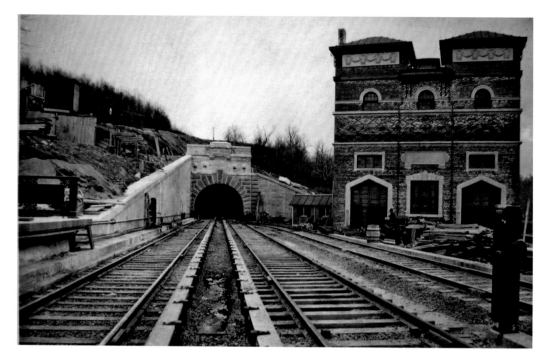

DYCKMAN STREET STATION: The opening of the Dyckman Street Station on March 16, 1906 premiered a design unique in the system and is listed in the National Register of Historic Places. The northern muddy wilderness and remaining farmland of Manhattan had been speculated for growth since the 1880s with proposed street layouts. But this duel platform station and masonry head-house just north of the Fort George Tunnel portal and the city's mountainous northern parks marked the areas inclusion with the rest of urban Manhattan.

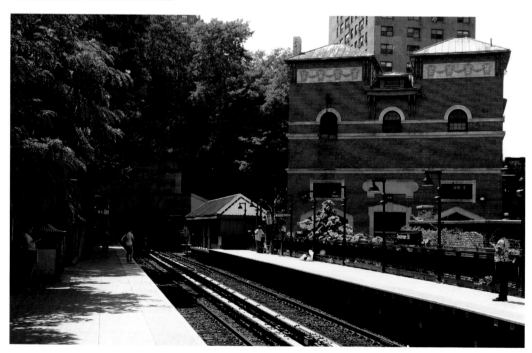

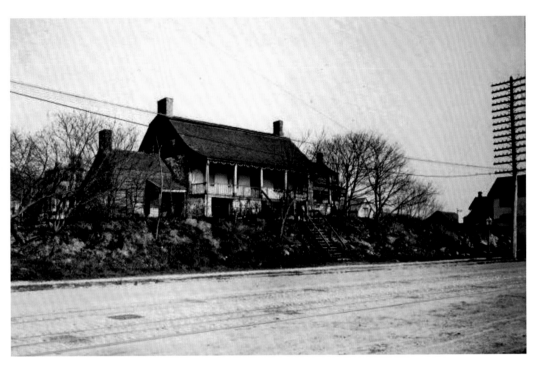

FARMING ON BROADWAY: The above image is from 1895, but the Dutch farmhouse had seen the dilapidation of neglect in its many weathered years. Built in 1784 as part of a 250-acre Dyckman family farm it is the last remaining example of Manhattan's rural past. But as the rest of the land became urbanized by 1916, preservationists stepped in and saved the farmhouse as a museum. It is now opened to the public at Broadway and 204th street.

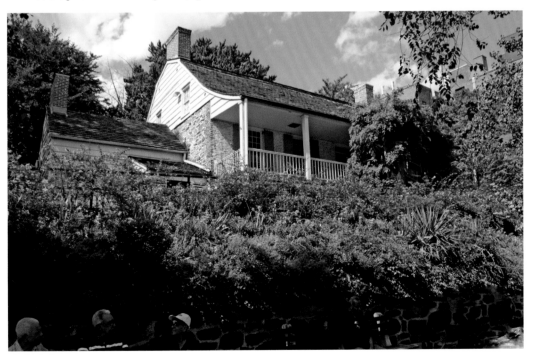

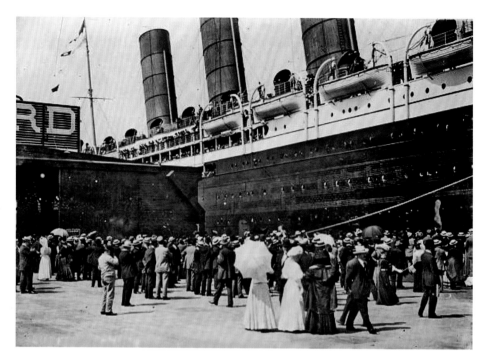

YOUR SHIP COMES IN: The crowds gather in 1907 for the arrival of the RMS *Lusitania* at the Cunard Line dock. The grand passenger liner's fate in history was to come later in 1915 when its sinking by German U-boat torpedoes killing 1,198 was instrumental in swaying public opinion for the United States to enter the Great War (First World War). Today moored, next to the Circle Line tours is the USS *Intrepid*. Launched during the Second World War it was decommissioned in 1974 and eventually made its way to New York City opening in 1982 as the Intrepid Sea-Air-Space Museum; the ship remains in this new "commission".

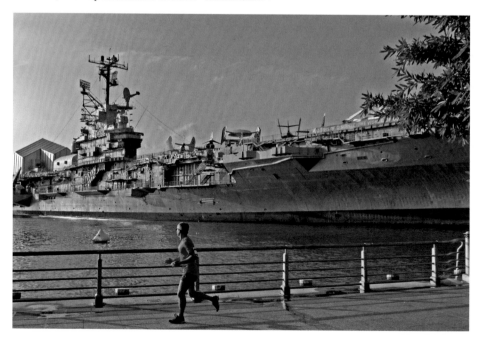

THE MANHATTAN PROJECT PARK:
The Western Electric Complex
(463 West Street) built in 1890 and
seen here in 1936, was at one time
the largest industrial research
center consisting of 13 buildings
developing innovations in telephone,
talking pictures (1923), B&W and
color television, as well as the first
commercial broadcasting of baseball.
The site was also the home for part
of the Manhattan Project during the
Second World War developing the
atomic bomb that would be dropped
on Japan to end the war. Today the
freight rail space has been replaced
to become the newly famed High Line
Park (see inset); an urban redo and a
unique public elevated green-space
promenade. The new park above
the streets on Manhattan's Westside
runs from Gansevoort Street in the
Meatpacking District to West 34th
Street, between 10th and 11th Avenues
with elevator access along the way.

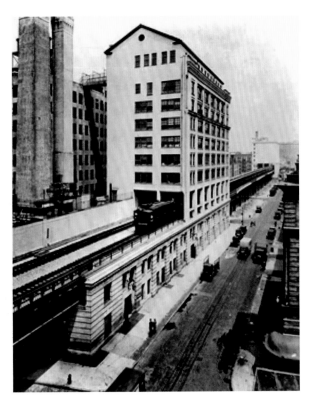

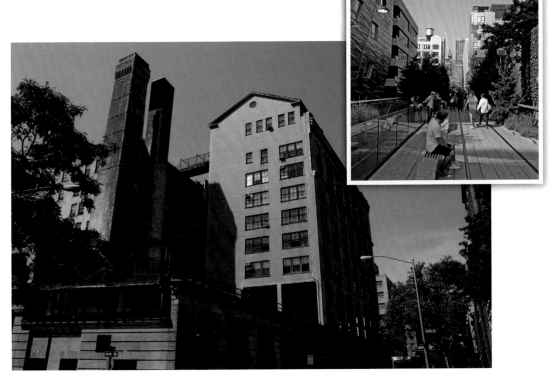

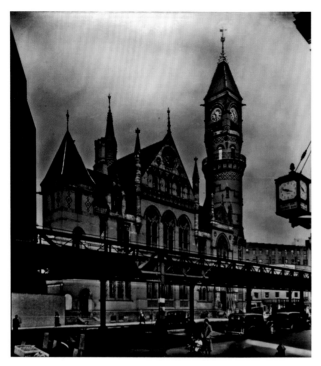

NEUSCHWANSTEIN ON
10TH AVENUE: One does not have
to travel to the Bavarian Castle of
the Ludwig II in Germany but just
visit Greenwich Village's mock
tribute. The Third Judicial District
Courthouse, built between 1874
and 1877 at the corner of Greenwich
Avenue and west 10th Street, had
originally been the site of the
Jefferson Market sheds since 1832.
But now a court house, its heavy
case load led to the first "night-
court" in the country. It would
handle the then *entertainment and
red-light section* of Manhattan that
would become known as the first
"Tenderloin". A late nineteenth
term attributed, according to the
Encyclopedia of New York City, to New
York Police Department Captain
Alexander S. "Clubber" Williams,
when he was transferred to the
police precinct in the heart of
this lower mid-town district. It
referred to the increased amount
of bribes he would receive for
police protection of both legitimate
and illegitimate businesses there,
especially the many brothels.
Williams said, "I've been having
chuck steak ever since I've been
on the force, and now I'm going
to have a bit of tenderloin". The
coined, perhaps code word would
be used by other American cities.

Scheduled for demolition by
1958, Preservationists and lovers
of Disneyland's Sleeping Beauty
Castle saved it to become a part
of the New York Public Library
system. Note above the IRT Sixth
Avenue Elevated Line in the 1935
photograph by Berenice Abbott.

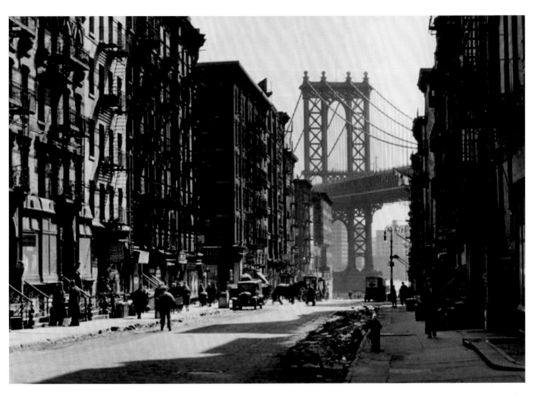

MANHATTAN BRIDGE TOWER: Pike Street toward the Manhattan Bridge in 1936, an iconic image by Berenice Abbott for the Federal Art Project (FAP) for her "Changing New York" project now part of the Museum of the City of New York collection. Aside from the Manhattan Bridge Tower, the neighborhood changes are evident in the image below, a view of the lower Eastside.

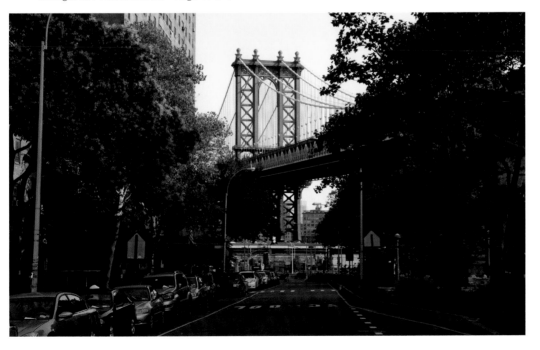

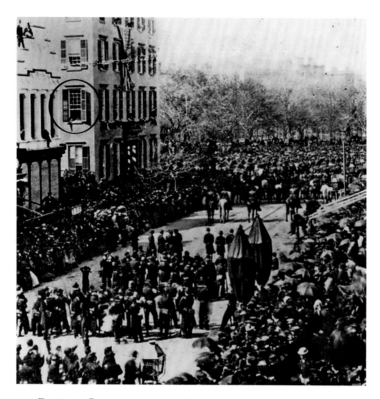

PRESIDENTIAL FUNERAL CORTEGE: Theodore Roosevelt at age 7 can be seen from the second floor window of his Grandfather's Union Square house just a few blocks from his Gramercy Park home. With him is his cousin, Elliot witnessing the funeral procession of President Lincoln that traveled about the country with "viewings" in 11 cities including this procession down Broadway. Below is the 16th President lying in state in the New York City Hall. Mary Todd Lincoln did not accompany her husband on this "dirge-march", but wished there were no pictures to be taken. This was the only surviving image. Apparently one New York press photographer Jeremiah Gurney, Jr., did not get the memo.

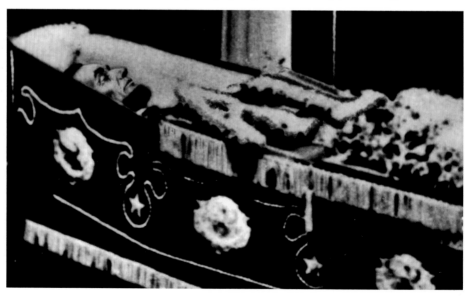

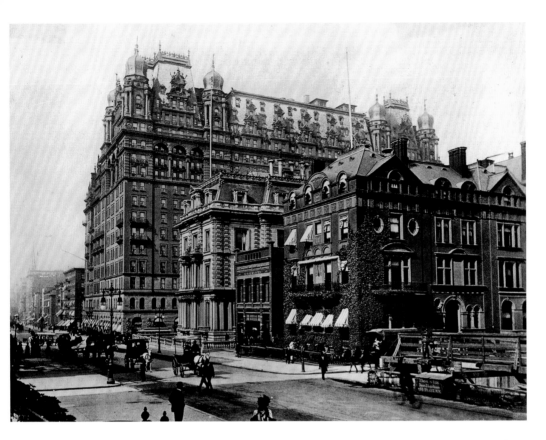

IT'S A BIRD; IT'S A PLANE: 34th Street and
5th Avenue, the block where the Empire State
Building looms, originally was the homes of John
Jacob Astor and other Astor family members. By
the late 1800s, on adjoining homesteads, because
of a personal feud, the family built two separate
competing hotels. With less intrigue, they would
eventually link, becoming the Waldorf Astoria;
the largest hotel in the world. 35 years later it
would become the site of the tallest building
in the world. At 102 stories, in 1945, it was
accidentally struck at the 79th floor by a military
plane, a precursor for the building that took up
the mantle in 1973 as the tallest building in New
York, the World Trade Center.

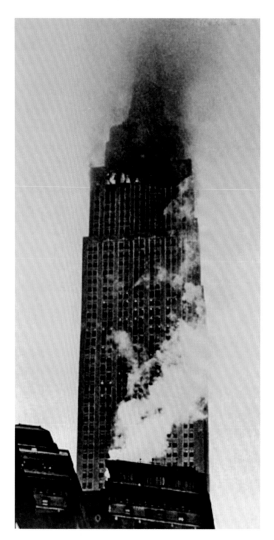

"TERROR ON THE 79TH FLOOR": A B25 Mitchell Bomber military plane on a routine transport mission looking for Newark Airport in 1945, lost visibility in the fog, and slammed into the north side of the Empire State Building at the offices of the War Relief, National Catholic Welfare Council on the 79th floor. Seen here from 33rd and Broadway, a horrific event that some New Yorkers were reminded of when the first of the two jet airlines hit the World Trade Center on 911. But among some of the amazing stories was that of a woman who was in a "severed cable" elevator as she plunged 79 floors to the third basement and, although as battered as the elevator, survived. To this day, a missing stone in the facade serves as evidence of where the aircraft crashed into the building.

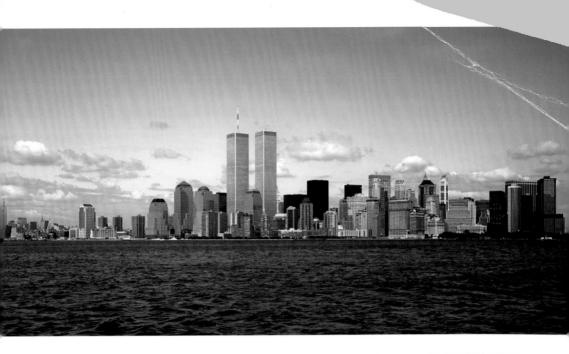

ANGELS OVER MANHATTAN: The World Trade Center seemingly dwarfing the Empire State building in the far right corner in Carol Highsmith's August 2001 New York skyline image.

Planning for the WTC originally started in 1943 for the east side but was put on hold in 1949. Momentum picked up again in 1961 favoring a west side location and moving the project forward with the original 80 story plan renegotiated to 110 stories. Construction started in 1966; ribbon cutting ceremony on April 4th,1973. And finally, an act of terrorist flying two passenger-filled airliners into and destroying the twin towers of the World Trade Center on September 11th, 2001. Ultimately, 2,756 death certificates were filed relating to the 9/11 attacks in New York and every year the date is commemorated with twin blue lasers pointed to the heavens on the original WTC site memorial so captured by Rolando Vasquez' image as the full moon passes in angelic remembrance.

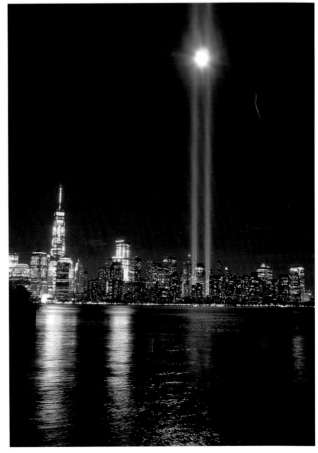

ACKNOWLEDGEMENTS

Beyond the yellowed photographs of a Manhattan long gone, the first tools in doing any research is "Wikipedia", or perhaps a good starting point, as well as Kevin Walsh's *Forgotten New York*. Cross-referencing stories helps flesh out the truth, or at least a "version" of the truth. Much can be found on websites of imaged subjects: The Apollo Theatre, National Parks, Roosevelt Museum, The NY Subway Museum, the New York Public Library, The Museum of the City of New York, and the New York branch of the National Archives, Battery Park. But the foremost for the archival images is the Library of Congress, prints and film division; the image history collectors never to be known, and those

who donated their archives:, Jack E. Boucher, Berenice Abbott, WPA, Joseph Byron, Carol Highsmith, and The Detroit Photo Company. Contemporary images, except where noted, are those of author/photo-artist, Frank Muzzy (with help from the weekly subway pass that magically transports to locations). Special thanks to Michael Mackenzie Wills for his encouragement, imagery, and motoring about Manhattan while humming Gershwin tunes, as well as "rib" meetings at the 23rd Street Dallas BBQ. Additional thanks to Rolando Vasquez' for his imagery and support, Andre Zoss, an obliging Swiss tourist for the back cover "author shot", the reliant tech abilities from my Parisian Pal-excellence', Bruce Lhuillier, and the appreciated editing skills of Alan Sutton, Jamie Sutton, and PR talents of George Kalchev at Fonthill Media.

For Barbara Cohan and her Ansonia roost, for "Birds of a Feather", Chris Bilski and his Boston retreat, and Rick Sughrue and Mike Grabowski and their Village out-post.

The Central Park Conservancy and a memory of a "Hansom carriage" ride around the park with a summer romance; or a snowy winter stroll through the Park and down 5th Avenue to Rockefeller Center's ice rink with its infectious holiday cheer.

To Bergdorf Goodman, my first credit card, and to Michael Henry of MDH Fine Arts Gallery for giving me my first New York art opening in Chelsea and to the happy hour at the Gym Bar sharing cocktails with the Santa from the Rockette's Christmas Spectacular.

For luncheons at the Russian Tea Room with Eileen T'Kaye, then supper at the Rainbow Room, "Top of the Rock", with Patti Cohenour and our dancing the night away at the "Phantom's" Tony party.

Grand bows given to Leanora Schildkraut for introductions around New York and Hollywood and her stories that warrant her own "Tales", and to Louise Hirschfeld Cullman and the Al Hirschfeld Foundation. To Carol Channing who played "Muzzy" in a movie and always pretended she remembers me. The cast of the "Chicago", 1975, and seeing my first Broadway show. What was your first Broadway show? And any New York plot based film that brings the romance and excitement to a little lad loving movies and where it took him, a big guy that loves walks in Manhattan after Midnight recalling his own *Tales of Manhattan Through Time*.